HIGHWAY 51

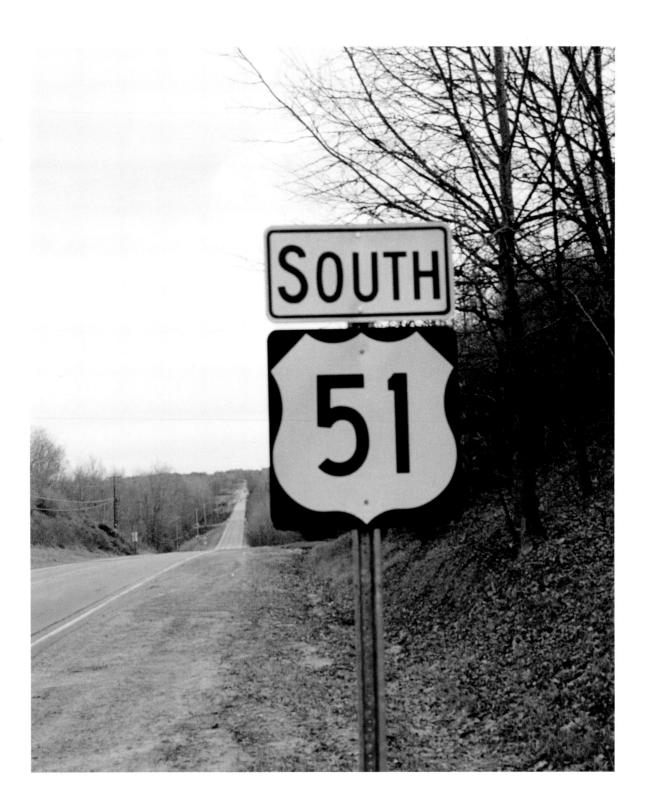

HIGHWAY 51

MISSISSIPPI HILL COUNTRY

Photographs by GLORIA NORRIS Introduction by RICK BASS

UNIVERSITY PRESS OF MISSISSIPPI

www.upress.state.ms.us

Designed by Todd Lape

The University Press of Mississippi is a member
of the Association of American University Presses.

Image page ii:
Highway 51 sign, near Benson's Store, Enid

Eudora Welty House photographed with permission
of Mississippi Department of Archives and History

Elvis image used by permission, Elvis Presley
Enterprises, Inc.

First printing 2009

∞

Library of Congress Cataloging-in-Publication Data

Norris, Gloria.
Highway 51 : Mississippi hill country / photographs
by Gloria Norris ; introduction by Rick Bass.
p. cm.
ISBN 978-1-60473-098-2 (cloth : alk. paper)
1. Mississippi—Pictorial works. 2. Mississippi—
History, Local—Pictorial works. 3. United States
Highway 51—Pictorial works. I. Title.
II. Title: Highway Fifty-One.
F342.N67 2009
976.2—dc22 2008044514

British Library Cataloging-in-Publication Data available

Dedicated to the memory

of my mother,

Mary Ella Turnipseed Norris,

and my nephew

Allen King, Jr.

INTRODUCTION RICK BASS

How paradoxical it seems that a road—a corridor through and across the land, constructed for the express purpose of transportation, mobility, sustained transience—should over time provide and create community. For as these photographs by Gloria Norris show, the hill country that attaches like a long muscle to either side of the spine of Highway 51 is one extended community, with gradations—some reaches more pastoral, others more wild, but all of a kind, somehow as unified, even in those tonal differences, as family.

Roads typically dilute communities, pouring in unfettered influences from the Great Outside; certainly, they can bisect and fragment that which is whole. Roads and other avenues of transportation tend to dictate the pace of the lives they touch, ever-accelerating those rhythms that might previously have been more leisurely, and long-established, durable.

And in this era of increased globalization, that may yet be the case for Highway 51, but it has not yet defeated or corrupted these communities; there is a spirit and ethos along this road that was surely there before the road itself, despite the many pressures that have been placed on it.

In this regard the highway possesses more the qualities of a river than a road, and I find it interesting that the route travels a transect that is roughly parallel to, and not all that far distanced from, the New Madrid Fault that delineates the Mississippi River, just to the west.

Like that great river, this space, this distance, transfers a more ancient spirit—one which preceded us by many millions of years—onto the newly arrived human inhabitants who cling here. Sometimes an ecologically impoverished land can yield extreme and ostentatious adaptations, in extreme responses to that difficult environment. While the hill country of Highway 51 has historically been anything but ecologically impoverished, there is of course very much a legacy of financial impoverishment—the land perhaps a little too rich, if anything, and therefore a little too tempting, attracting the barons and despoilers corrupted by their absolute power.

Always in nature—human or otherwise—there is response-and-counter-response. The fast-fading of physical things in this landscape, and the exuberance of rot, of seasonal vegetative uproar, contributes to a spirit and ethos in which memories and stories almost

always persist longer than the physical elements of their stories. Here perhaps more than anywhere, the new quickly becomes camouflaged with the old, and in this melding, there is neither ruination nor even dilution, but instead—thus far—sustenance, as Norris's photos reveal, again and again.

. . .

The road that is defined by the contours of the hill country helps determine, not surprisingly, not just the spirit of the place, but the types of art—further expressions of that come from that country. The fundamental geometries of man-in-landscape, seeking to impose order, or at least establish and then cling to order, in that rotting, ever-fading (and ever-being-reborn) landscape: Norris sees them clearly, these little zones of casual conflict and tension so subtle that it seems no longer so much like tension as instead a weary truce, negotiated not so much by the efforts of either party, but some larger force, some larger desire that instructs, in this place at least, mankind and landscape to meld.

Bare limbs, purple storm-skies, the brief wintry pauses between tumultuous growth, and the outlandish fecundity in some of these images, once fall

and winter depart: again, the spirit of the land conveys itself to the spirit of its inhabitants, and Norris portrays it elegantly. In some of these photos, even the land itself appears worn out and rotting—not so much beaten as just resting. Not as beaten as the paint-peeling buildings, but worn down a little, by this business of trying to support the curious presence, curious existence, of humanity.

In Norris's photographs, the vertical structures—telephone poles and wires, phalanxes of graveyard headstones, and the molded circularities of man-made items—ovals of sunhats, or cookie jars, or the curve of the Illinois Central's steel rails disappearing into a deep thicket—seem to stand illuminated in the more complex and sophisticated scramble of nature, where an infinite interconnectedness and sometimes secret logic makes our own geometries look childishly simple. You see it, this man-and-nature negotiation, not just in the art and architecture of the region, and in Norris's photos, but in the music and literature of the hill country—in Mississippi John Hurt's insistent rhythms; in Larry Brown's great American novel, *Joe*; in the sagas from Faulkner's Big Woods, or the quiet but powerful internal dramas created in Eudora Welty's home in the suburbs; in Richard Wright's unquenchable insistence upon dignity, and outrage and lamentation at its absence; in Elvis Presley's irrepressible caterwauling . . .

Spirit. Against a fast-fading and economically impoverished land, the shout of color draws one's attention, is worn like a badge. Norris has an eye for the cooling sultry power of deep blue and purple, and, above all, an eye for red, contrary cousin to that most common color in the hill country, the midspectral value of green.

Red, in rust-washed sheets of tin; *red*, in Richard Wright's brick wall-sign; *red* in the soil that made the bricks; *red* in the blood of the inhabitants of this place, no matter their skin color.

Spirit and spirituality. Many of Norris's photos depict the presence of twentieth-century hill country Christianity: not so much the formal orthodoxy of that religion, replete with custom, tradition, ceremony, and structure, but instead the social and cultural element of it, and the almost desperate touchstone of it that is still prevalent in the heartland and yet at times so vexing or outright puzzling to those living on the East and West coasts. The photographs do not judge the religions, nor do I mean to, in discussing them; I raise the issue only in the context of the larger and more pervasive spirituality that emanates from all of these photos, of both the landscape and the people, whether they are on their way to church or not.

· · ·

Landscape equals culture. Cut a stripe through this rich soil, a long furrow scratched thinly through the loess and richness of immemorial floodrot, and this is what flowers and dies, flowers and dies, year after year and generation after generation: the subjects in Norris's photographs. Rot can yield only more rot in the end, but in between the rotting, there is great joy, if almost always too brief.

NOTES FROM THE PHOTOGRAPHER GLORIA NORRIS

Bob Dylan made Highway 51 famous in his sixties hit of the same title, singing the blues of a man who fears his 51 girl doesn't love him. However, we who lived on this thoroughfare running from Memphis to Jackson shared none of the song's mournfulness about the highway. We were always excited to travel north on 51 to Memphis to shop at Goldsmith's, visit the Memphis Zoo, or savor the elegance of the Peabody Hotel. We were equally excited to travel south through our sister towns to Jackson to visit the Mississippi State Fairgrounds, the stores on State Street, and the spacious Jackson Zoo.

Outside Mississippi, most people think the state consists of one vast flat Delta farmland, filled with giant white plantation homes and stretching south to a small fringe of Gulf Coast. In fact, Mississippi is much more complicated—made up of eight distinct regions, each shaped by differing geology that has created diverse economies and cultures.

The subject of this book, the Mississippi hill country, focuses on the north-central region of the state bisected by Highway 51, as it runs south from Memphis, Tennessee (about fifteen miles above the Mississippi border), southward generally through the loess hills two hundred miles south to Jackson, Mississippi. This area stretches about twenty to thirty miles on each side of the highway. Dr. John Ray Skates, author of *Mississippi: A History*, calls this region "one of the defining areas of the state."

Highway 51 binds together twenty-five towns that are united in a spirit of kinship and style of culture. Here the hilly soil is the color of terra cotta; the climate is violent, slashed by frequent tornadoes that yank solid buildings into the air. We are also visited by frequent rains—so many different kinds that we can speak of "a good rain," "not much of a rain," or "a real bad rain" or "a *terrible* rain." Our seasons include a sudden March spring (announced by the first dogwood trees blossoming in woods); a fierce, brutal summer lasting through September; a pretty fall; and short winters.

The people of 51 are deeply religious, and signs beside the highway constantly remind travelers that "Hell Is Truth Seen Too Late" or "If God Is Your Copilot, Change Seats with Him." Panola County still holds illegal the sale of alcoholic beverages, though citizens can drive a short distance south to visit the County Line Liquor Store near Como.

From this harsh land have come an astonishing number of world-class writers. Our writers include William Faulkner, Eudora Welty, Elizabeth Spencer, Stark Young, Richard Wright (who spent a formative period in high school in Jackson), and poet James Whitehead, as well as younger writers like Richard Ford, Larry Brown, Beth Henley, Donna Tart, Rick Bass, and John Grisham.

Perhaps this extraordinary literary outpouring is abetted because talk is one of the major ways of dealing with life. One morning Mrs. So-and-so's daughter wakes up sick. By the end of the day, the story has been repeated and embellished so many times by so many imaginative retellings that her illness has become epic, perhaps caused by her husband, or a stray dog, or some other evil force. Perhaps writers also draw on the mighty tradition of preachers' sermons—masterpieces of oratory. All of us are touched by the frequent hard times, which formed a tradition of making do through stoicism, pride, endurance—and quite a bit of storytelling.

I left this world in the early sixties when I went to New York to make a career in book publishing. As an aspiring actress at the University of Southern

Mississippi, I had modified my Southern accent—so much so that when I went for job interviews, editors asked if I was from London. It only took me a few weeks to work myself across the Atlantic and become employable.

Yet whenever I returned home on the plane to Memphis and through the small window glimpsed that red soil of my birth, quite against my will, tears rose to my eyes. *Home.*

Whenever I returned, I would rent a car at the airport and drive home on 51 south, never on the new Interstate 55 with eight lanes. By 2001 I began to notice that slow as change came to the South, the physical world of my youth was disappearing more on each trip. The beautiful people-made buildings painted in bright outlandish colors were being left to fall apart. In their place arose shopping centers filled with boxy WalMarts with their vast treeless parking lots, along with national franchises like H&R Block or McDonald's that increasingly made us identical to the general American landscape. The old pine trees lining 51 and shielding off the bright sun were slashed down to make room for "gated communities" composed of lookalike houses that featured alien interpretations of roofs and no porches. The old environmentally wise homes built with deep porches to keep off the sun and steep roofs to deflect the heavy storms of rain were replaced by flimsy buildings heated and cooled artificially. Aged cedar trees that had shaded houses for more than a century had been replaced by frail Home Depot saplings that would take twenty years to cast any shade.

A physical world was disappearing. I wanted to record it before it did. By the end of the seven years I worked on this project, much of it was gone. While I understand new generations must re-create their own time and place, I wanted to fix on paper the personal idiosyncrasy and often environmental wisdom that had gone along with deep porches, strategically planted trees, and the wisdom of carpenters as opposed to marketing specialists.

Yet some things endure. In this modern MP3 player world, most hill people still play instruments and sing as their chief form of release and entertainment. The Duck Hillbillies, many of whom toiled at nonunion jobs at what was then the Heatcraft plant (where air conditioners are still made under a shifting series of foreign ownerships) continue to perform with their old fiddles and bass—instruments often bought long ago at Western Auto stores, which for some reason also sold, alongside their car parts, used fiddles, dulcimers, and other instruments. The band is in great demand for all kind of occasions but refuses to take money for their playing. "Because" as Curly Rainey, a cofounder and noted mover of houses says, "we didn't want to make it work." Also in demand are gospel groups like the Smith Brothers, who stay busy between their jobs bringing their soul-stirring gospel music to weddings, concerts, and church services.

The large contingent of hill blues musicians (who play in a slightly looser form than traditional Delta blues musicians) are becoming even more recognized internationally, with practitioners like the recently deceased R. L. Burnside and his longtime guitarist Kenny Brown; the late Junior Kimbrough's son, David Kimbrough; the Mississippi All-Stars; and the Thacker Mountain group, which plays from Oxford's famous Square Books. Mississippi John Hurt, whose unique blues and guitar technique stunned and inspired young players like Bob Dylan and Joan Baez when he first appeared at the Newport Jazz Festival, contributed to the music of a generation. His shotgun home in the high Teoc hills continues to be an international drawing place, where visitors from Russia and Norway mingle with visitors from Mississippi and the states. Other great hill blues musicians who have only recently passed away are Jessie May Hemphill and Otar Turner, who lived to be over a hundred years old. Alan Lomax recorded Turner's music which drew inspiration from Civil War fife bands.

And then there is the behemoth Elvis, whose home, Graceland, sits on the outskirts of Memphis, where Highway 51 briefly turns into Elvis Presley Boulevard. In the years since his death Elvis's fame

has grown to new audiences. Recently, the Cartier Museum in Paris, which usually devotes itself to modernist art, featured a show about the music of Elvis and other rock and roll and blues musicians launched from Sun Studio, the famous recording studio still open on 51 as you approach downtown Memphis.

The highway also holds dark, violent memories of the sixties. Today the old route has poignant markers commemorating the sacrifices of the Civil Rights movement. The Lorraine Motel in Memphis, where Martin Luther King was killed, is now a museum that draws thousands of visitors. In Jackson, the home of Medgar Evers in a quiet suburb is a painful reminder of his murder. However, change is evident everywhere in integrated public schools and colleges. Most of the towns along 51 have or have had black mayors. In 1999 the William Winter Institute for Racial Reconciliation was founded at the University of Mississippi to promote diversity and civic renewal.

Dylan's "Highway 51" now appears on YouTube, accompanied by many postings of appreciation, but it's time for the photographs to tell the story.

Note of Appreciation

I want to thank Mary Alice White, director of the house of her aunt, Eudora Welty, for allowing me to photograph in the beautifully preserved home. I thank Mary Hurt Wright for granting me permission to photograph at the home of her grandfather, Mississippi John Hurt. I am deeply appreciative to Craig Gill, editor-in-chief of the University Press of Mississippi, for his fine editorial skills and his unfailing calm; my nieces Olivia, Pamela, and Gloria for their unflagging interest; my husband who drove me often on the highway with enthusiasm matching my own; and especially the good people of Highway 51 who shared their memories and knowledge of the world of Highway 51.

HIGHWAY 51

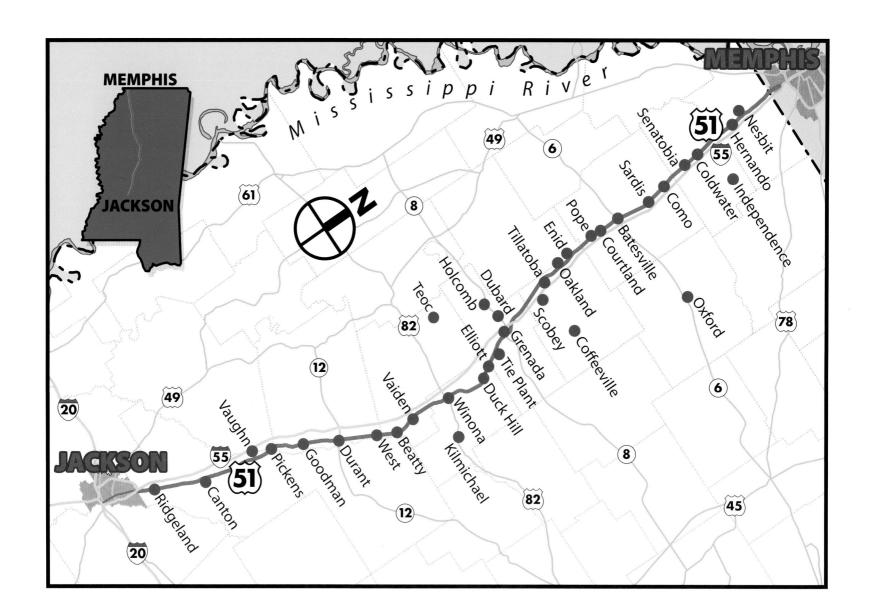

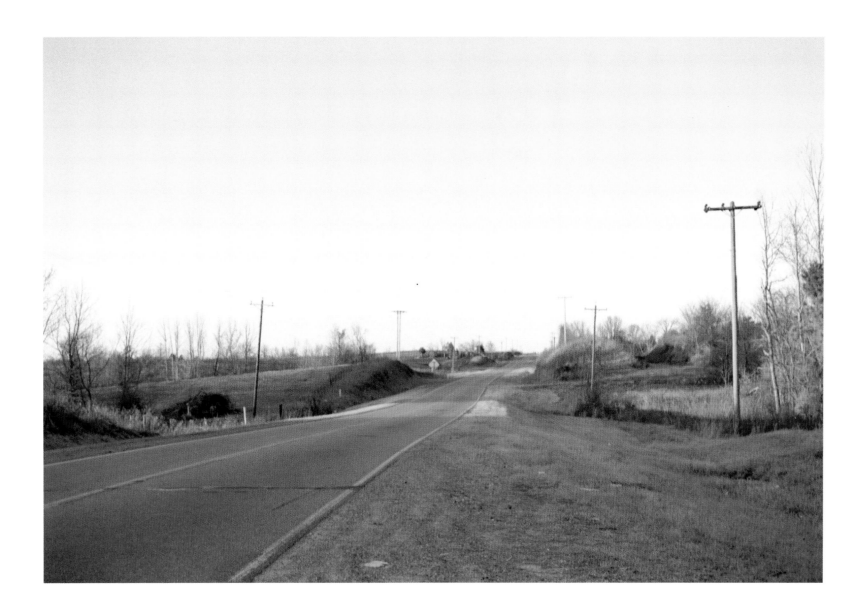

Highway 51 in winter

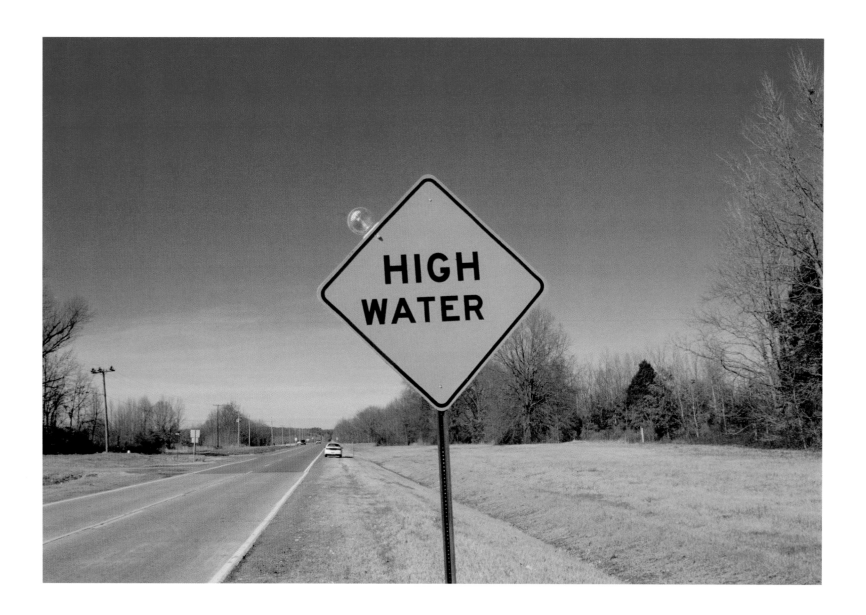

High Water, Coldwater

Landmark Ritz Café, Durant

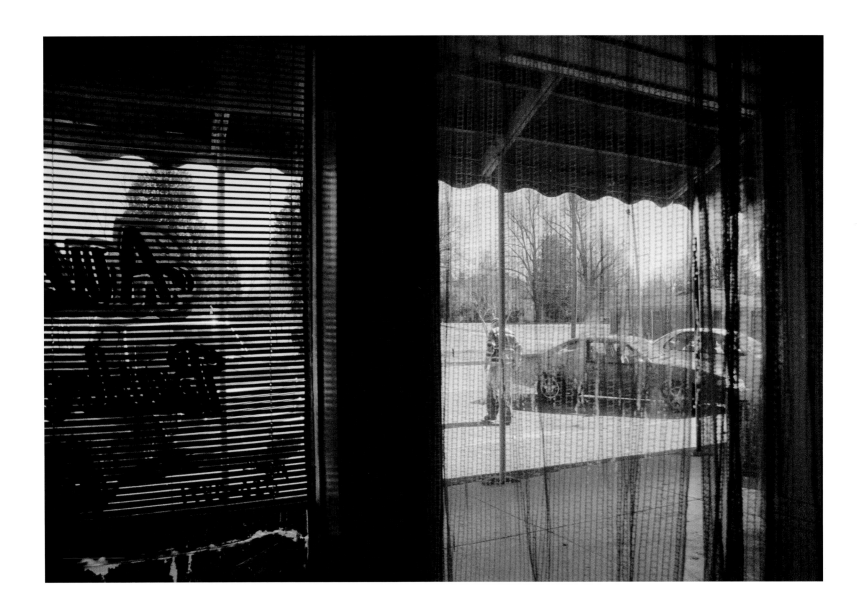

Dinner time, Como

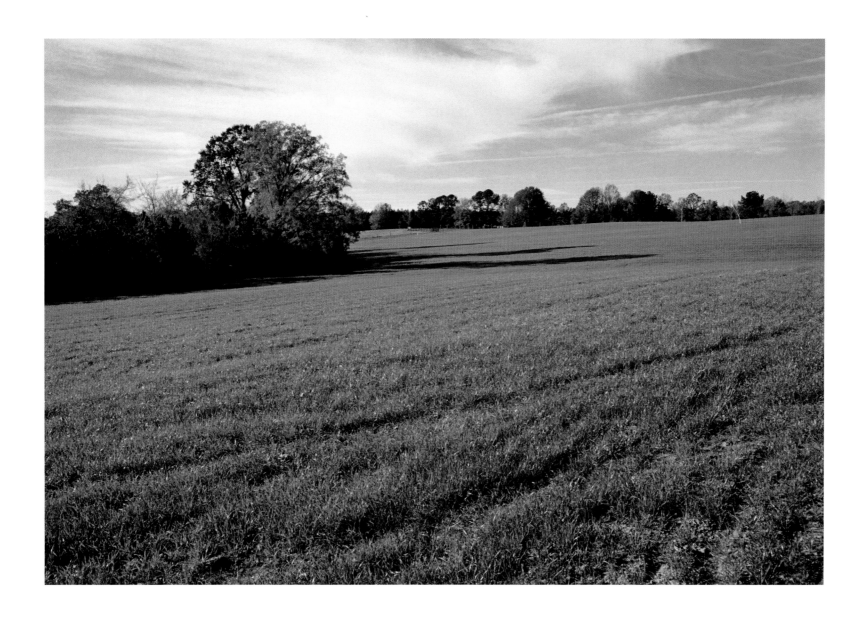

Land where Treaty of Doak's Stand was negotiated and Choctaws ceded land to white settlers, 1820

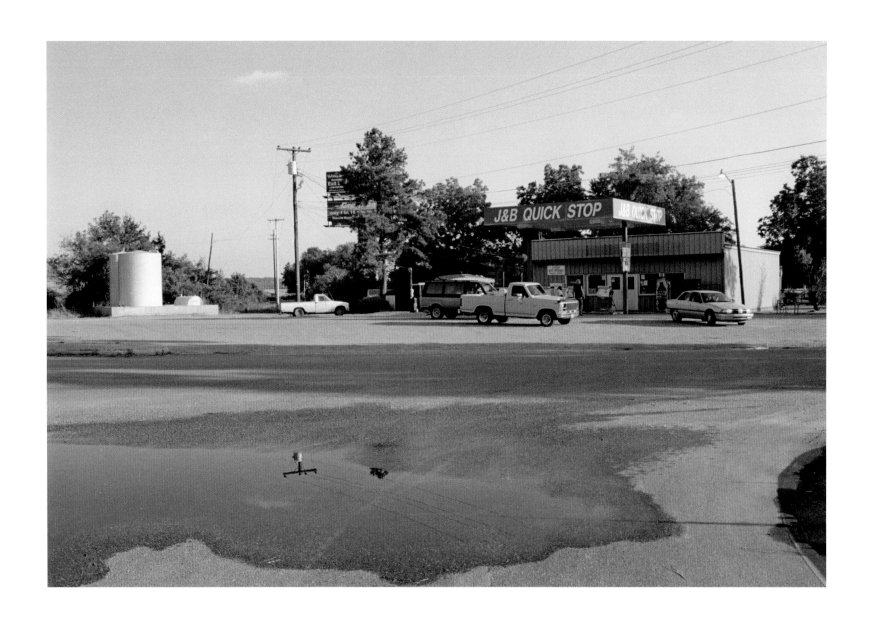

Sunday morning, Geeslin's Corner, where Highway 51 and 55 intersect

8

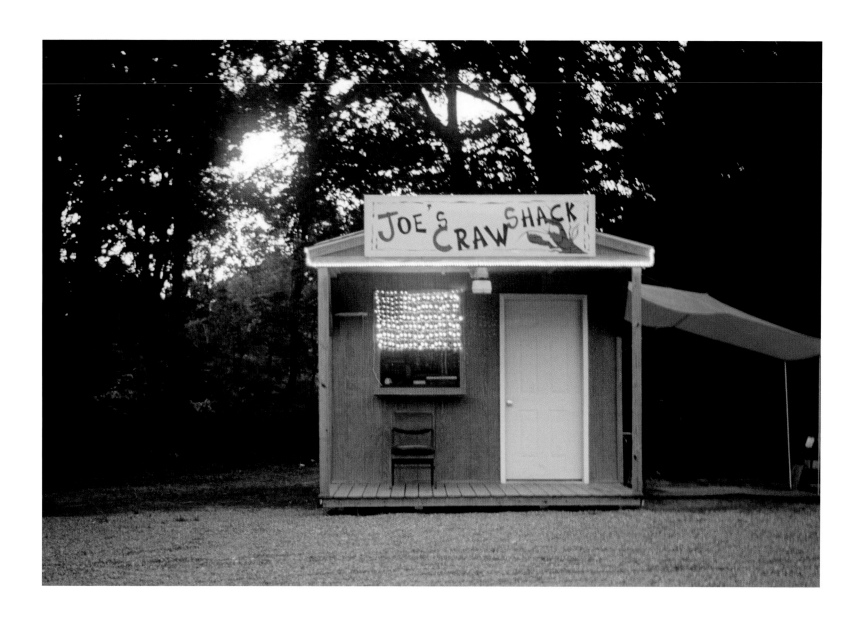

Joe's Craw Shack, 7 PM, temperature 101 degrees

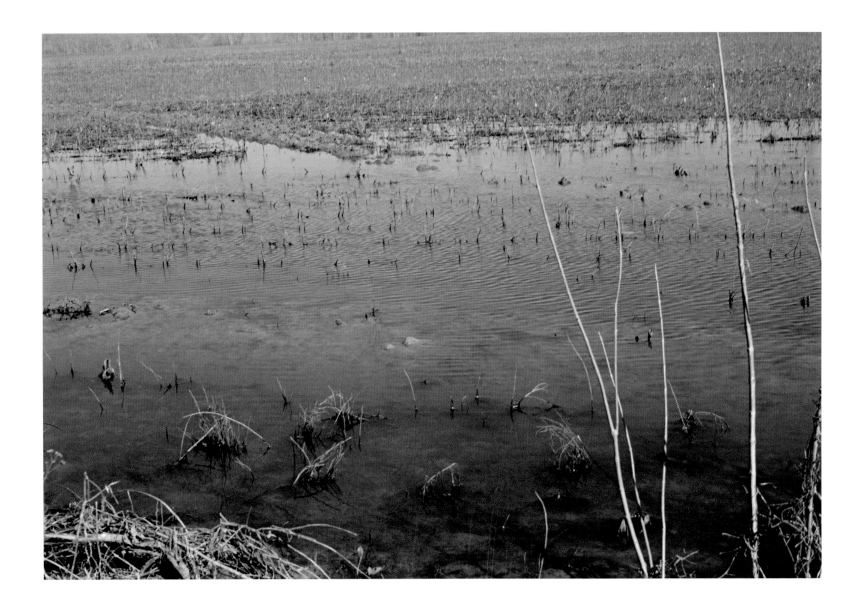

Yellow swamp

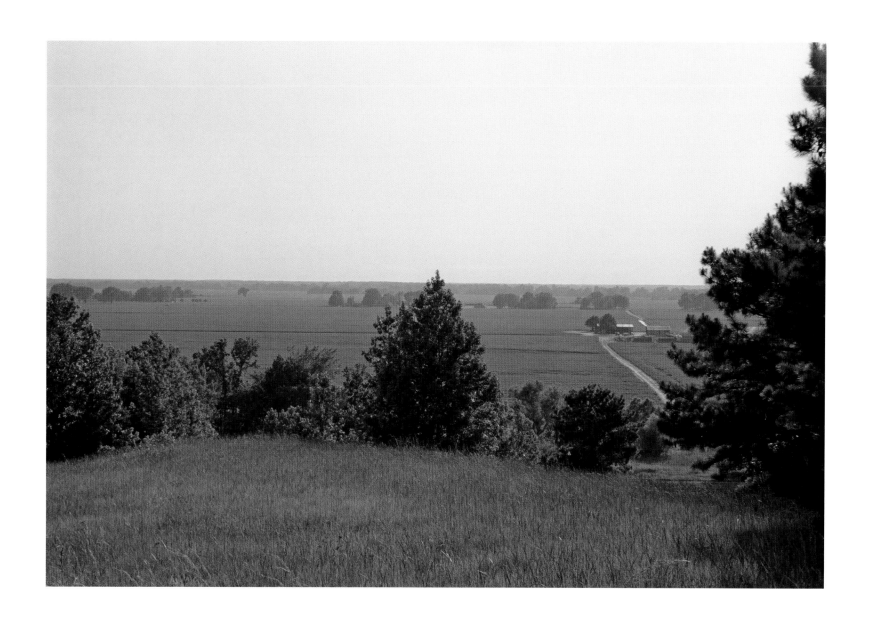

View of the Delta from Teoc Ridge

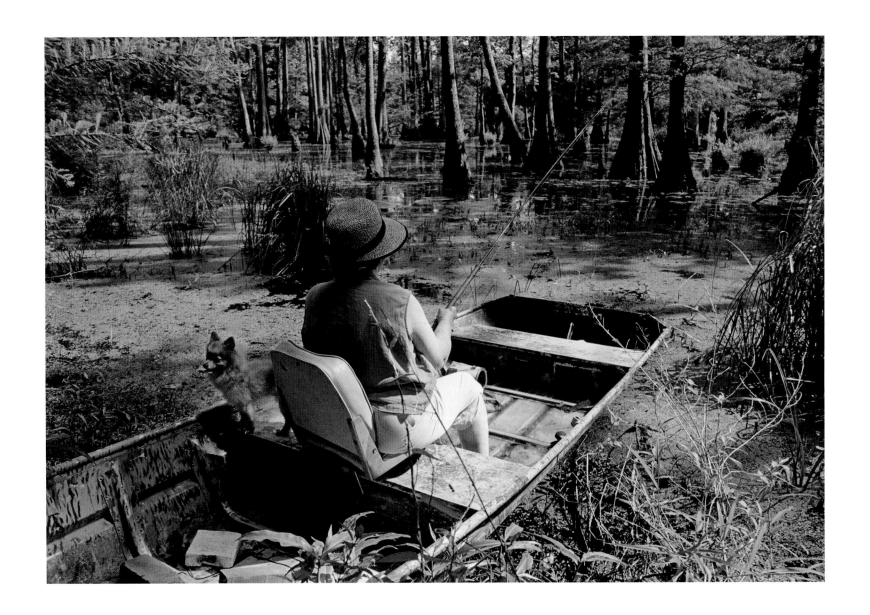

Lady fishing with her dog

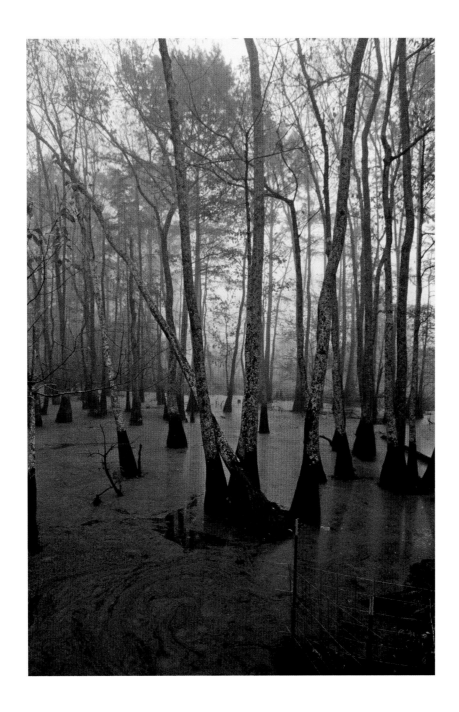

Green swamp

13

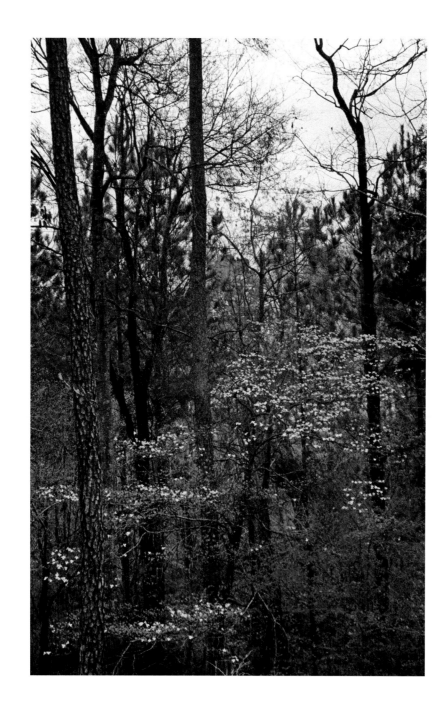

First dogwood announcing spring

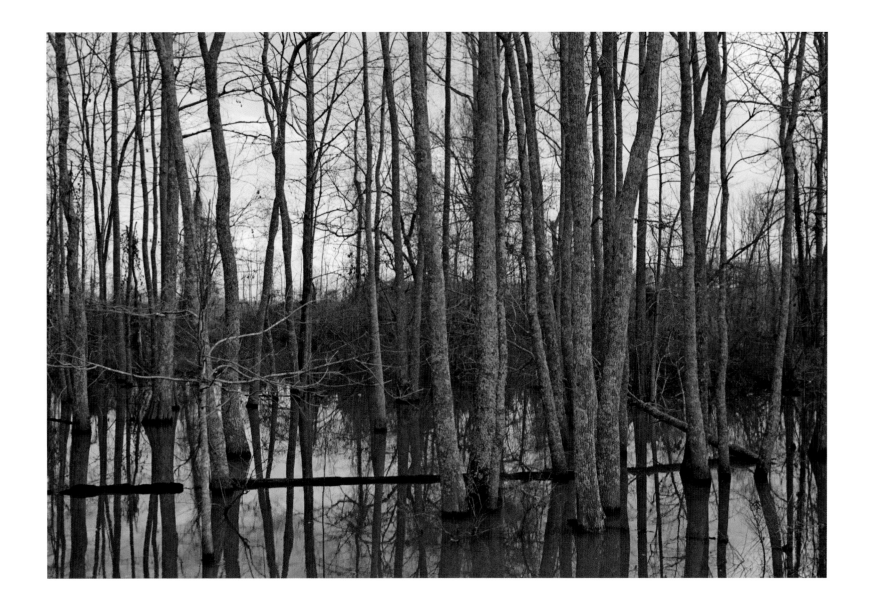

Blue swamp

Land where Treaty of Doak's Stand was negotiated

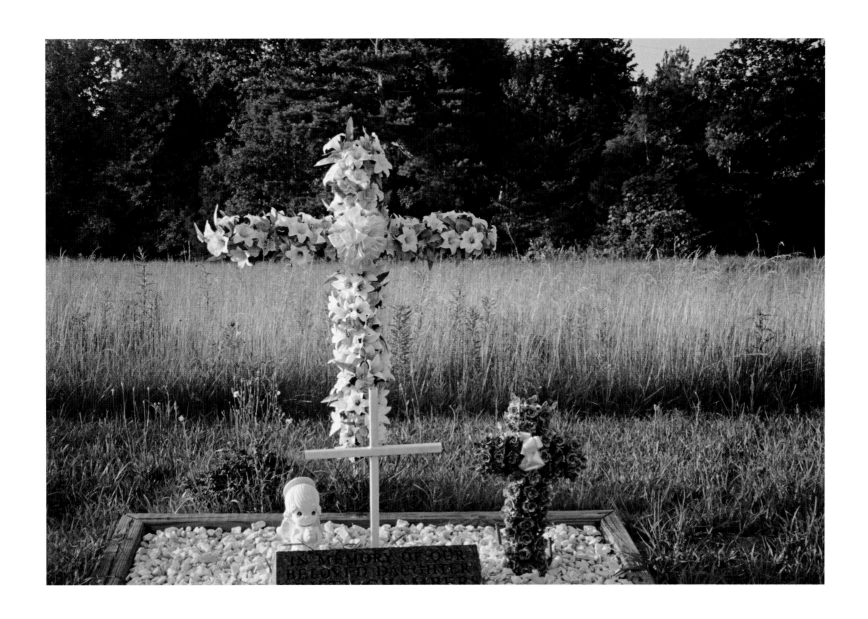

Christa's cross on Highway 51, memorializing a young woman
killed in a car accident. The flowers are changed each month.

17

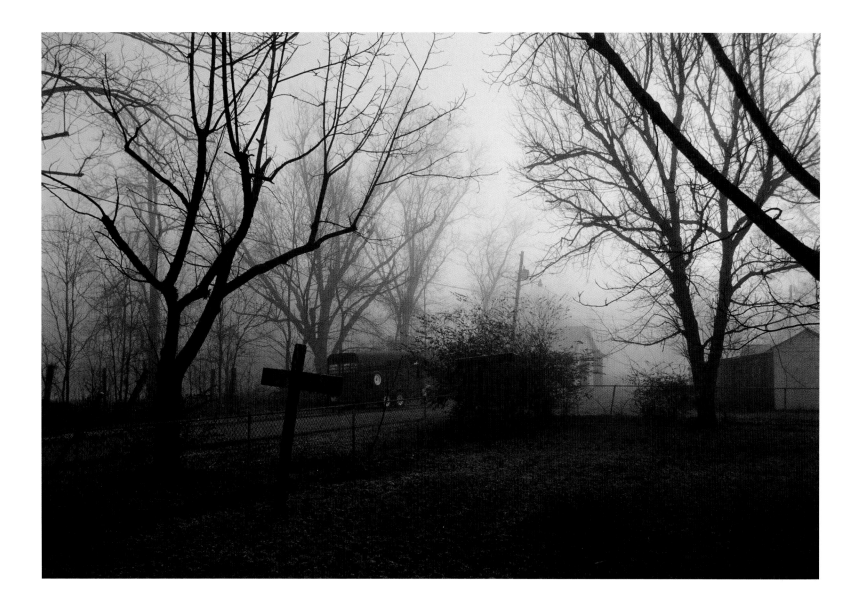

After a good rain

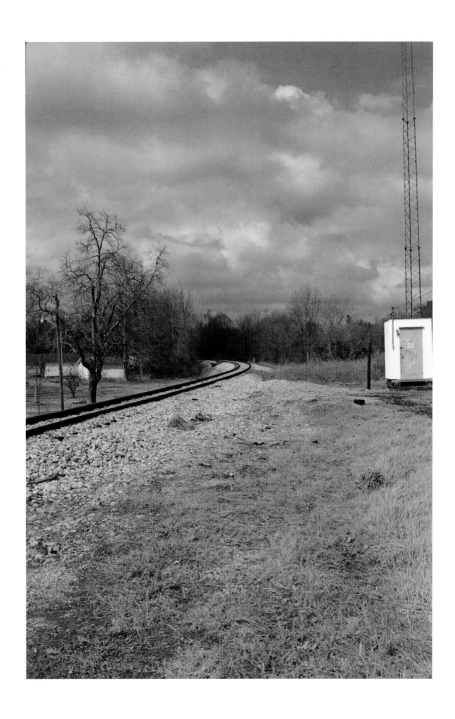

Illinois Central tracks at Tillatoba

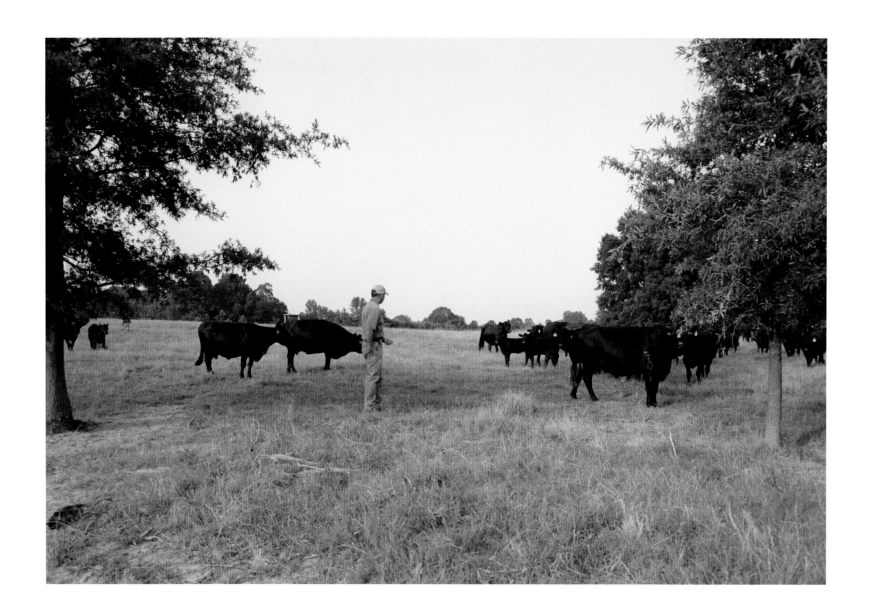

Cattleman, Como

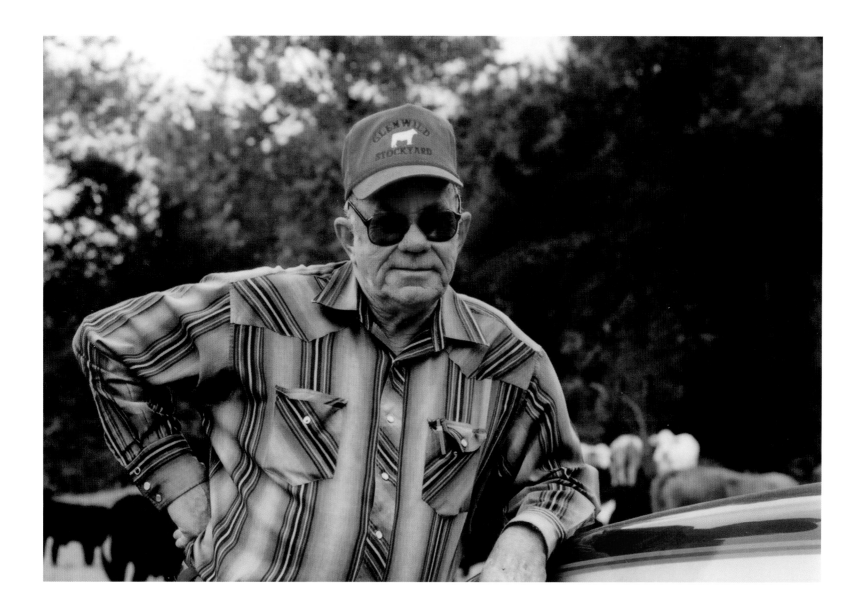

Cattleman, Sparta Road (near Holcomb)

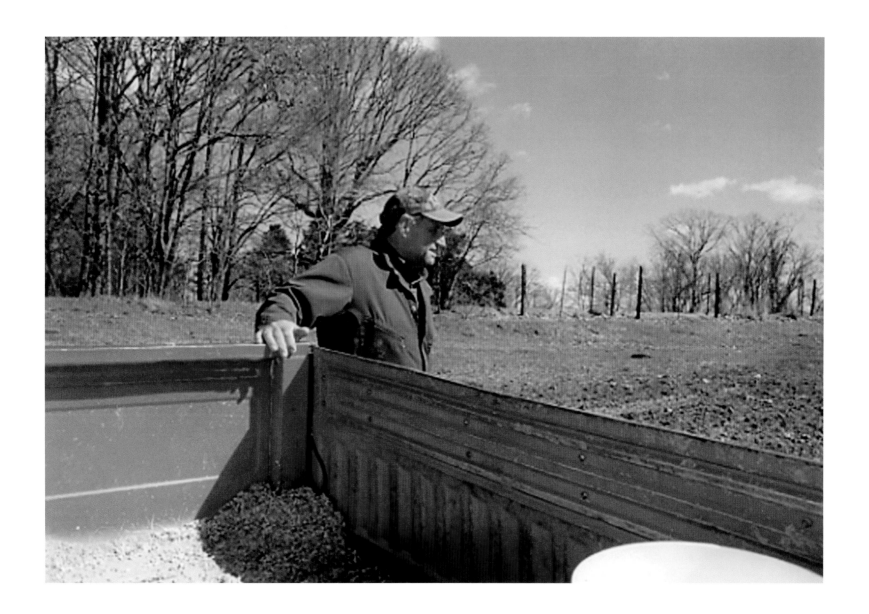

Cattleman, Grenada County

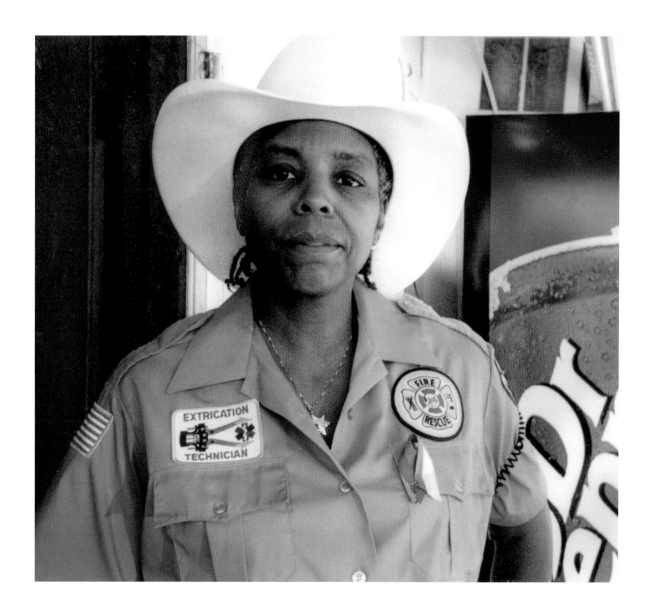

City worker, Vaiden

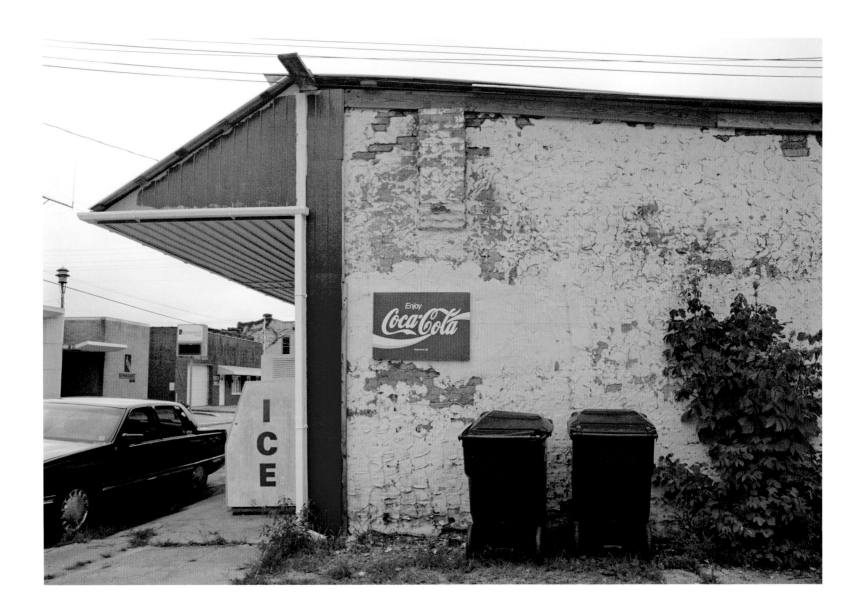

Store, Coffeeville

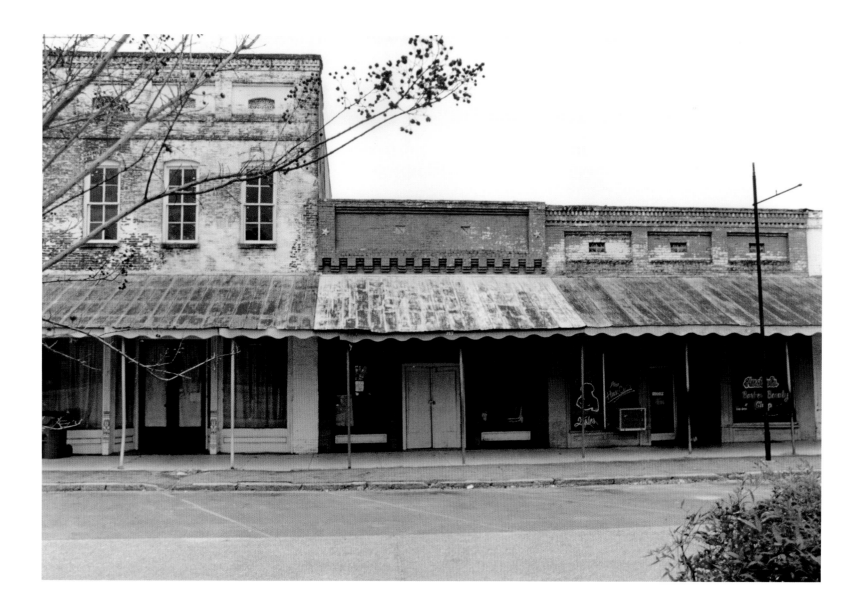

Downtown Como

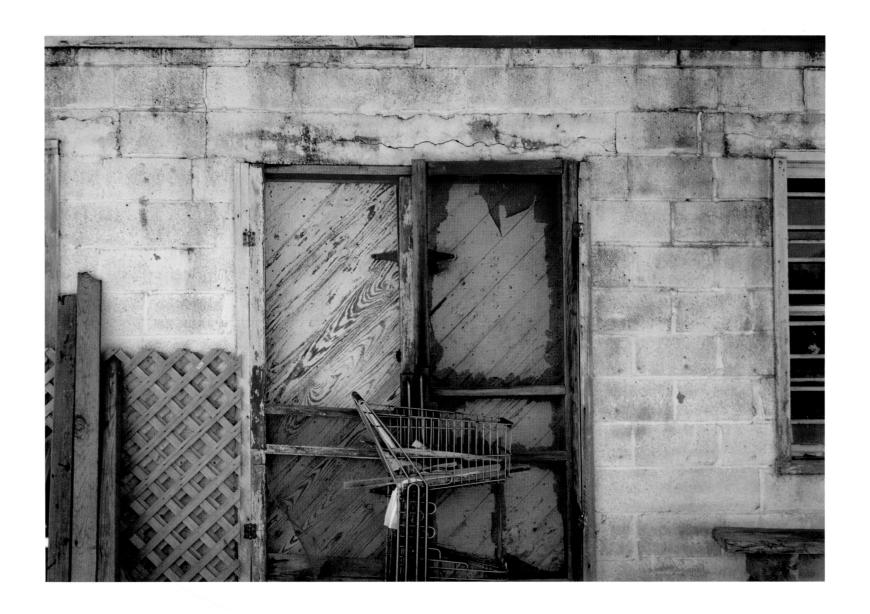

Store closed down after a murder

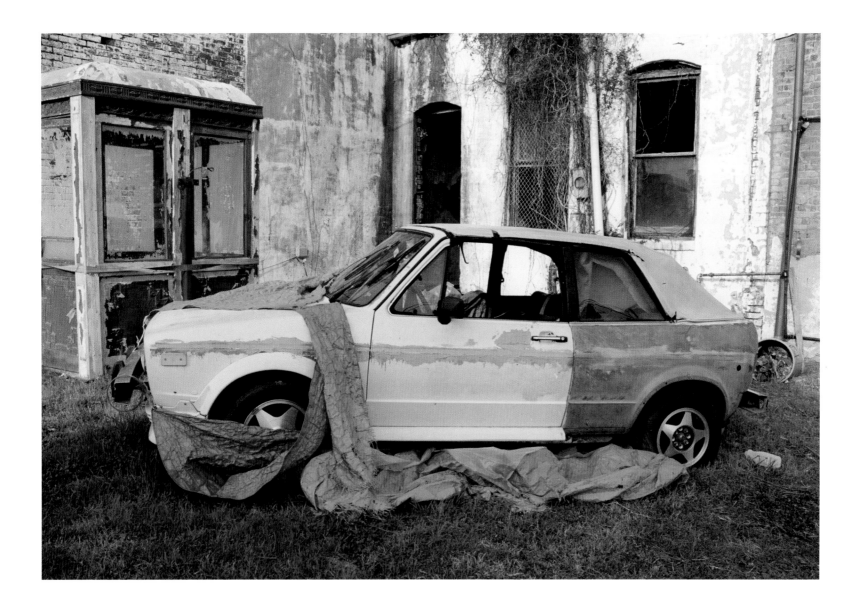

Car in drapes

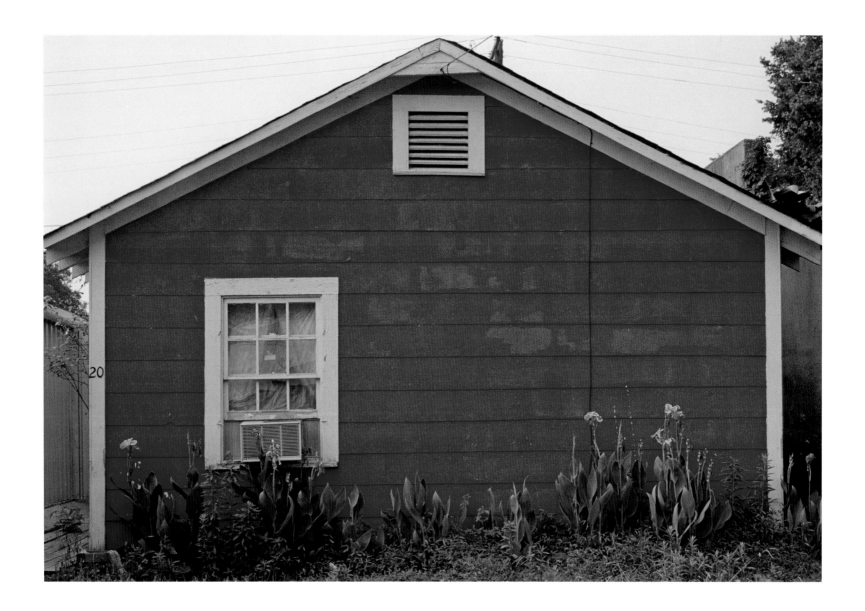

Red house with lilies

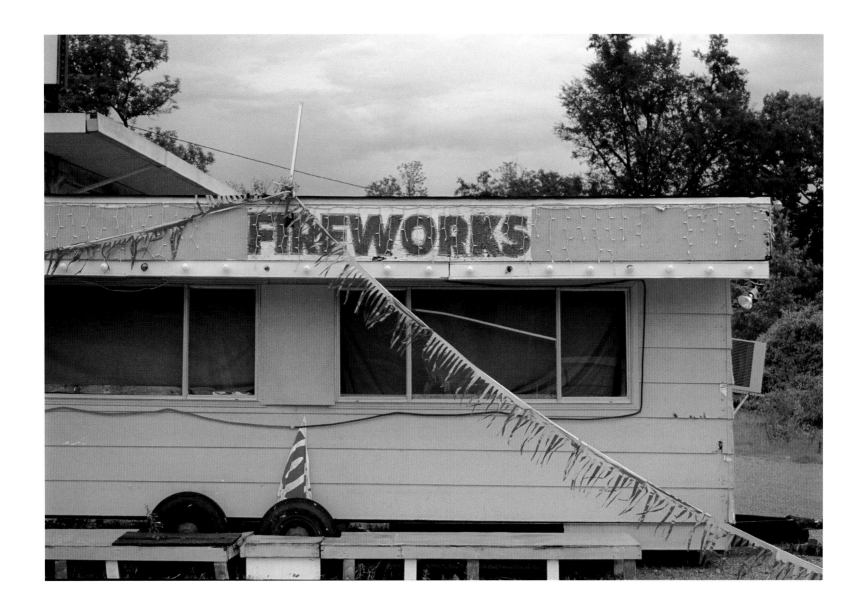

Fireworks trailer

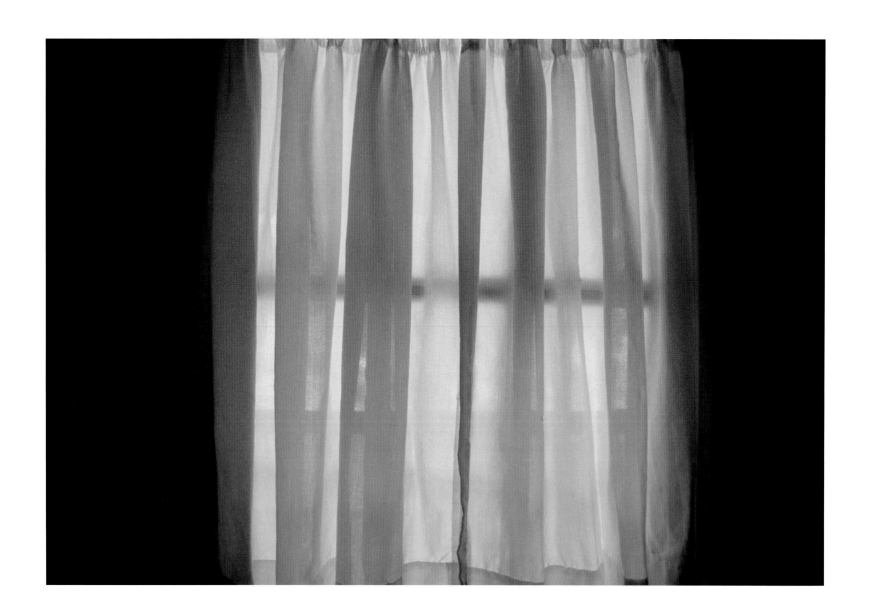

Sunlight at 3 PM

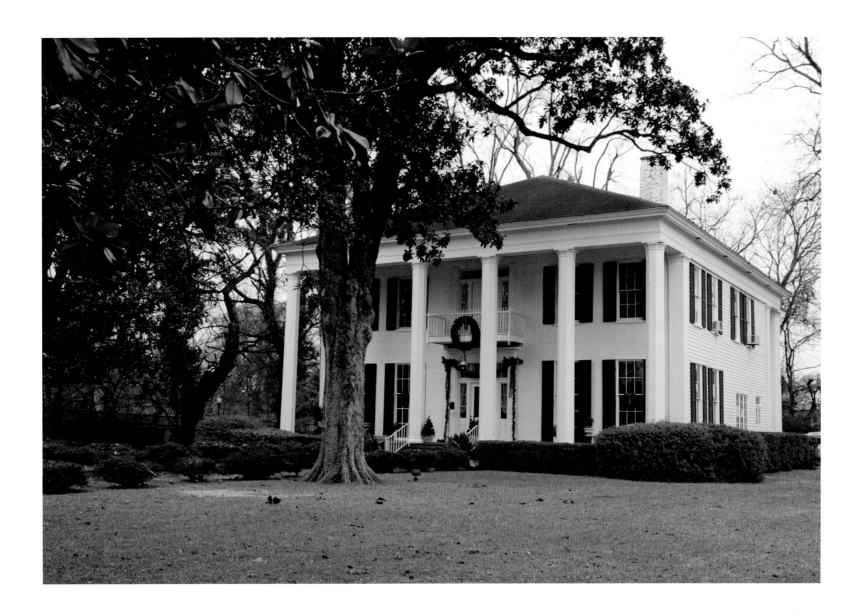

Haunted antebellum mansion, Grenada

William Faulkner's woods, Rowan Oak, Oxford

Faulkner's door leading to Rowan Oak grounds and stable

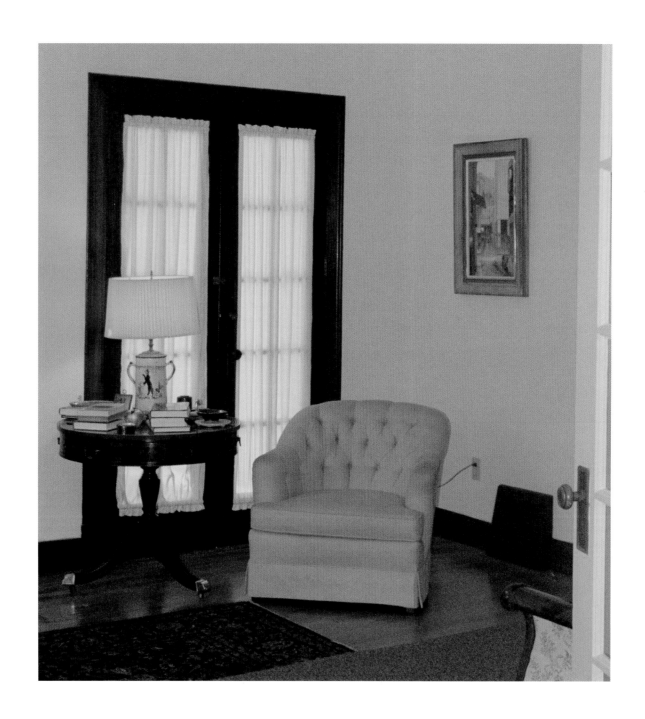

Eudora Welty's reading chair, Welty House, Jackson

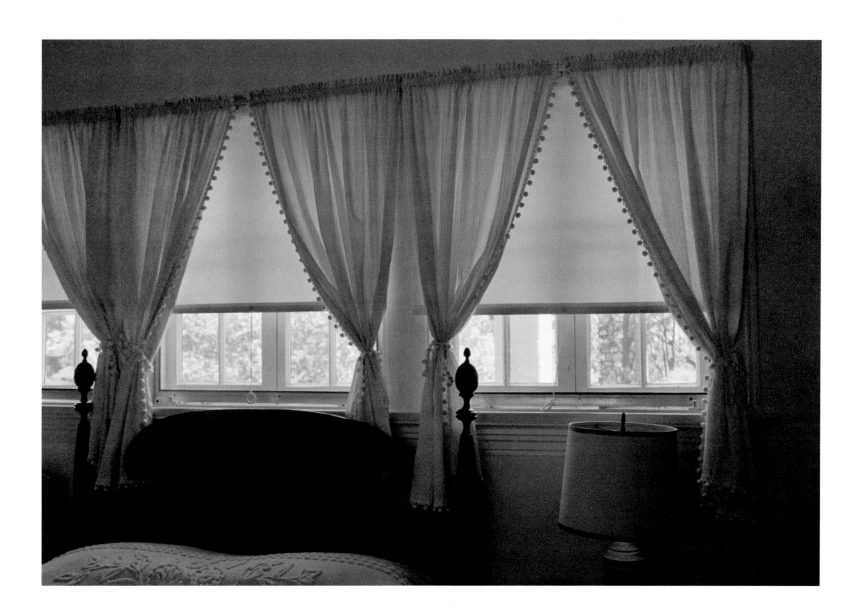

Welty's bedroom

Welty's kitchen

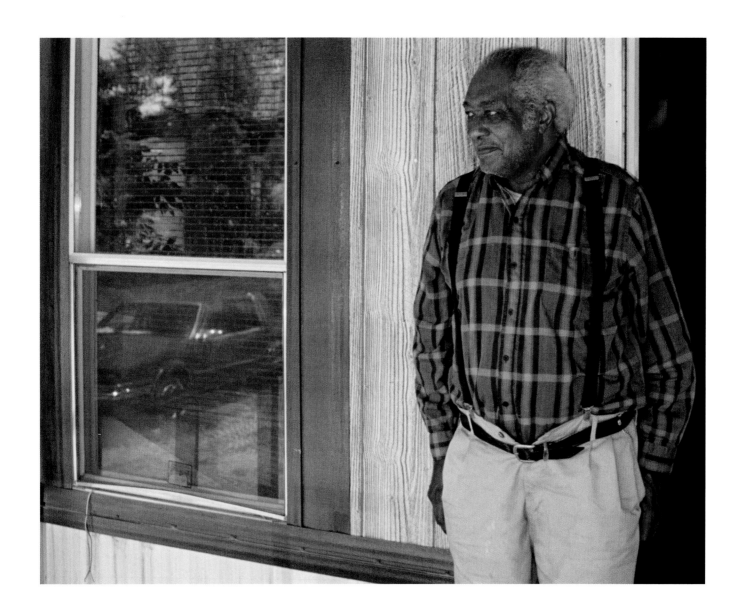

R. L. Burnside on his front porch, Independence

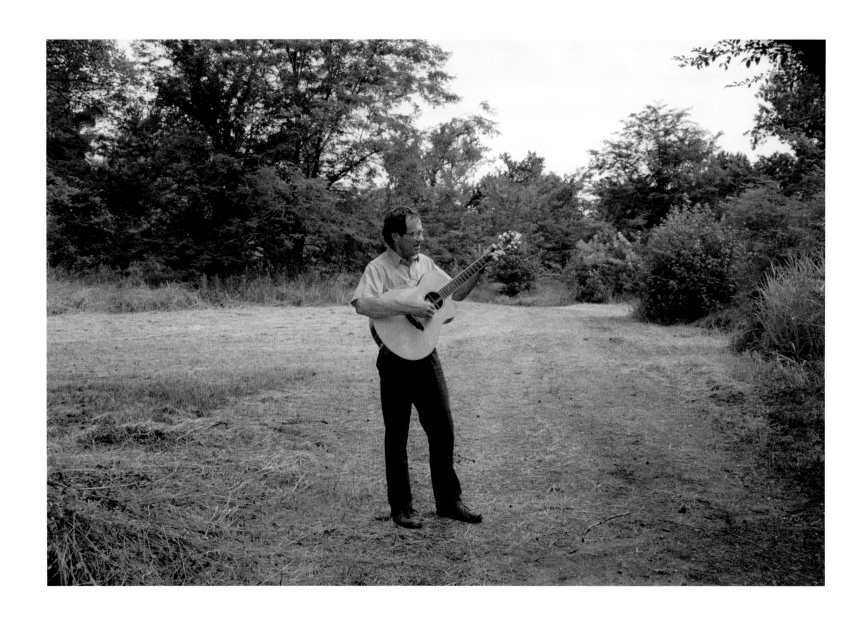

Guitarist Art Browning in his front yard, Teoc

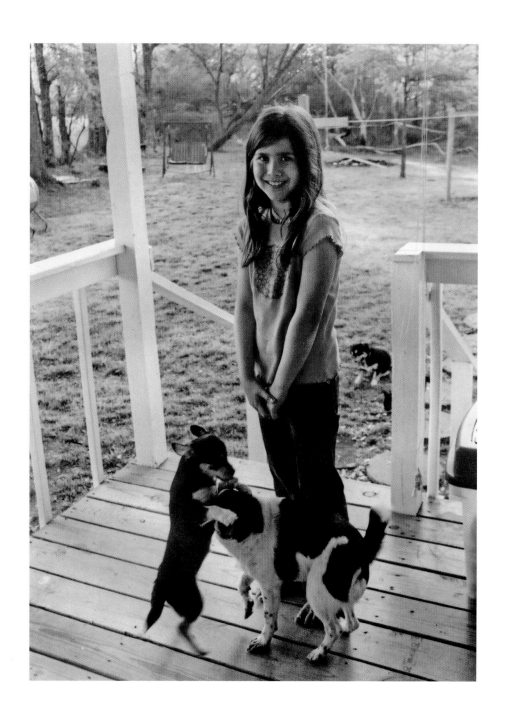

Young girl with her puppies

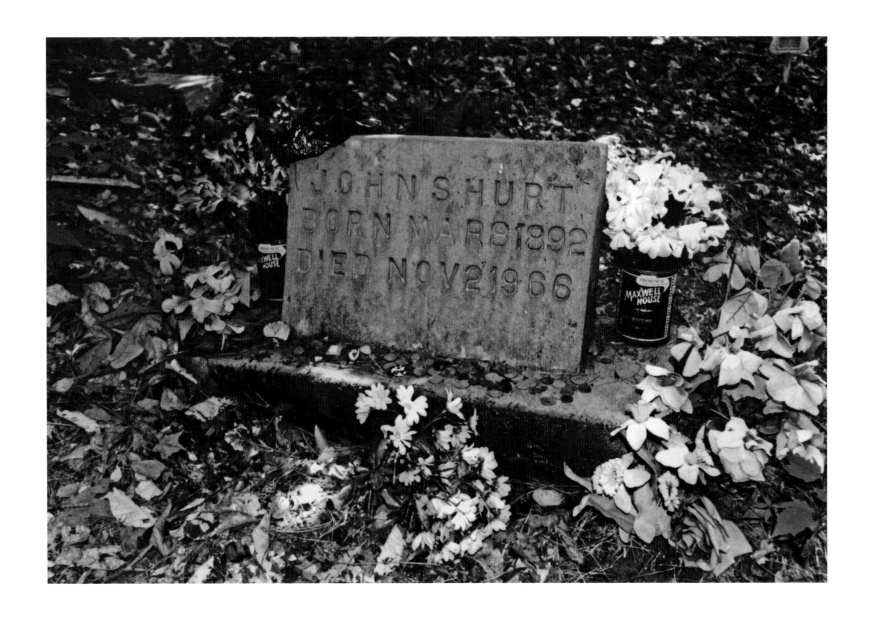

Mississippi John Hurt's grave decorated with gifts of coins and
Maxwell House coffee cans in homage to his great blues song

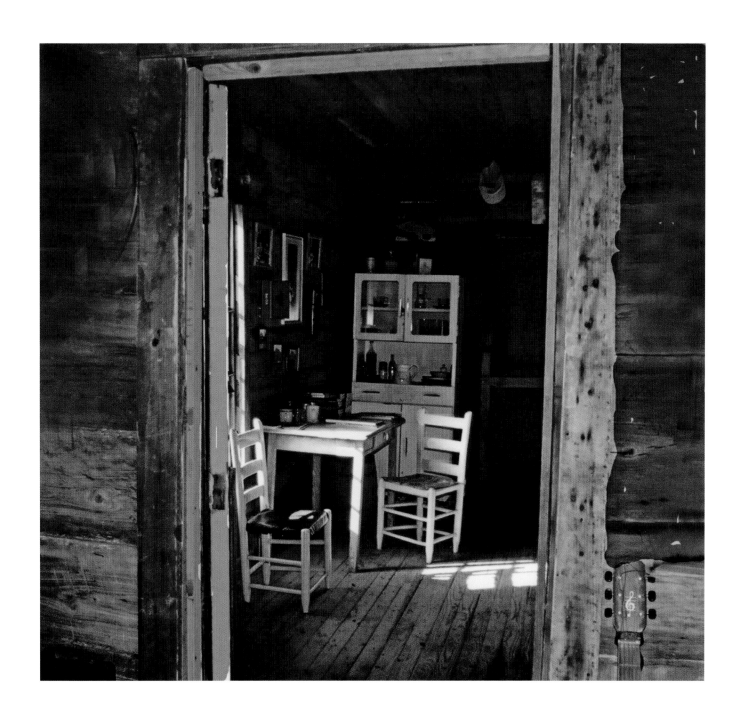

Mississippi John Hurt's kitchen, Teoc

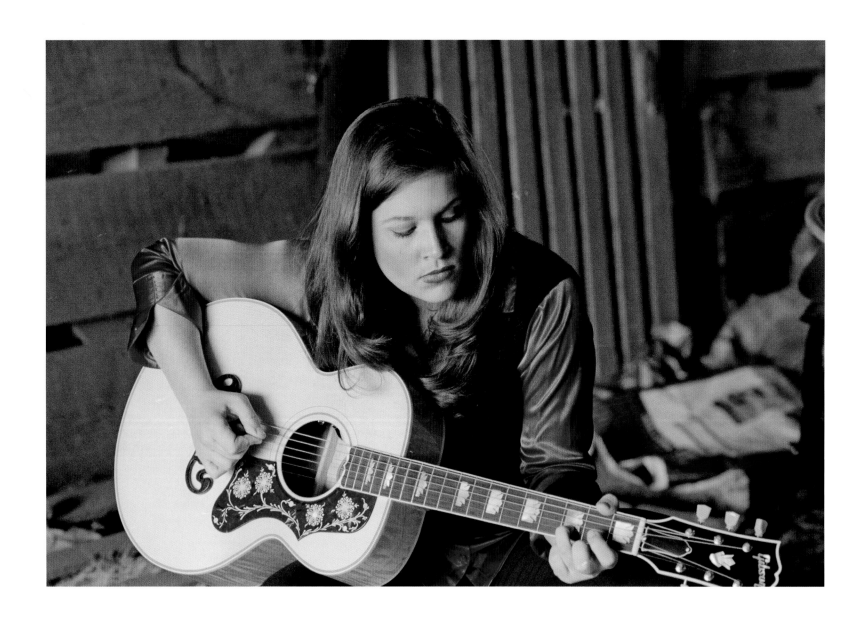

Karen D'Ambrino, singer-composer, Dubard

Lester Senter Wilson, opera singer, Jackson

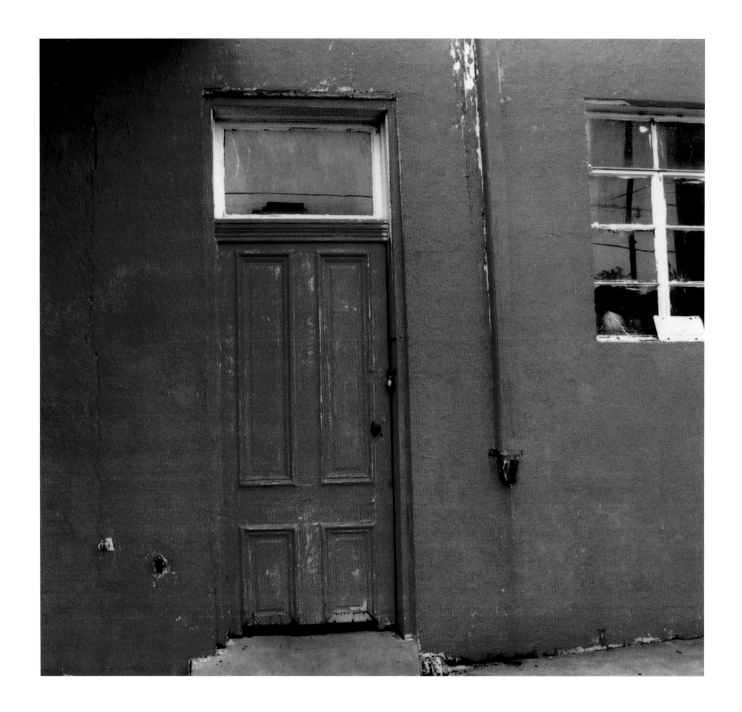

Pimento door

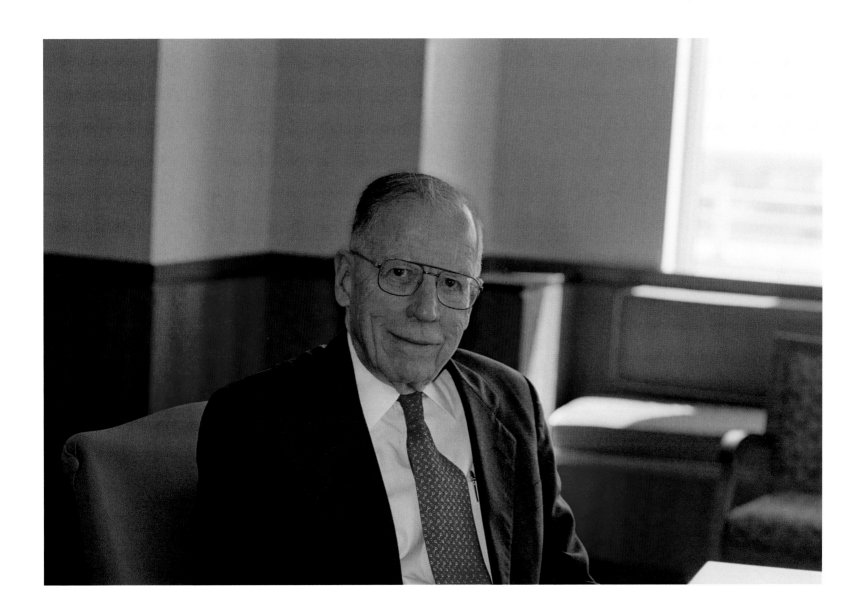

William Winter, governor of Mississippi, at Mississippi Historical Society

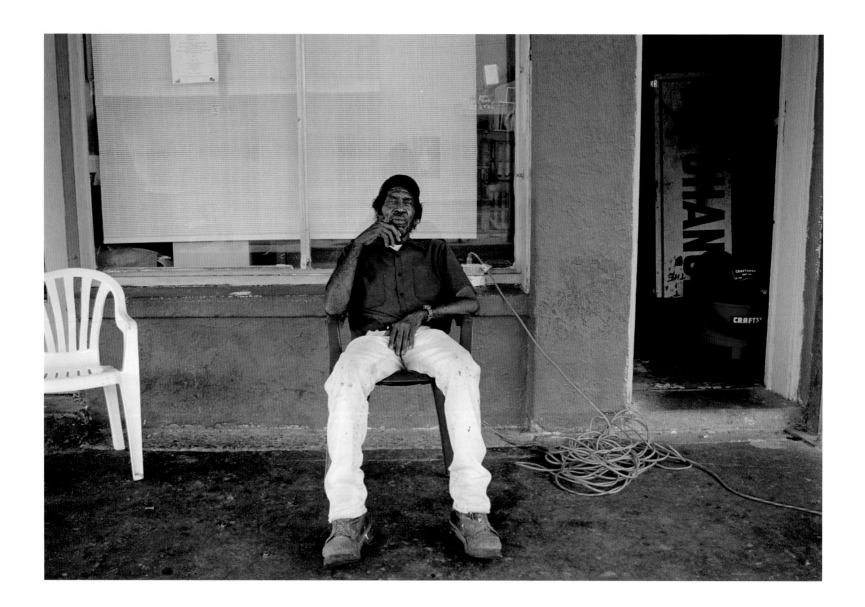

Pimento building

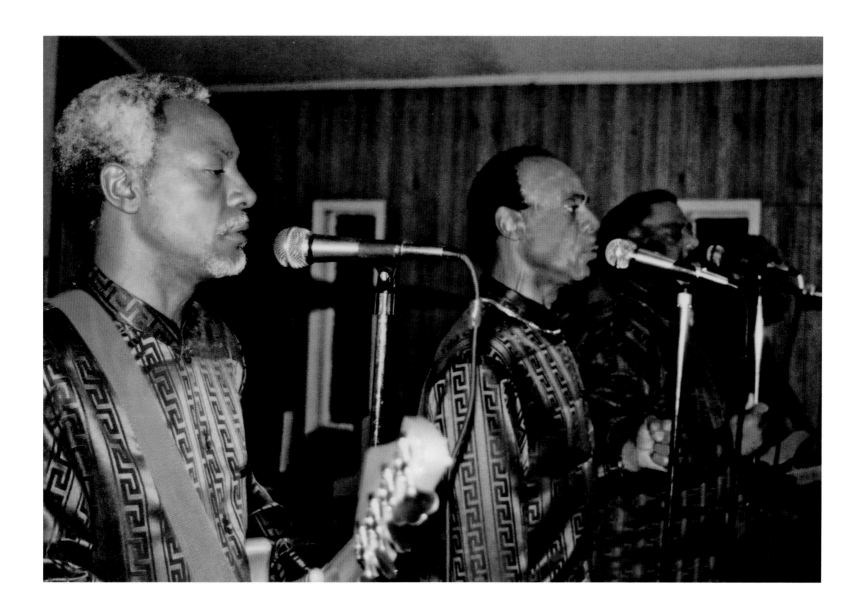

Smith Brothers gospel group at a church fundraiser

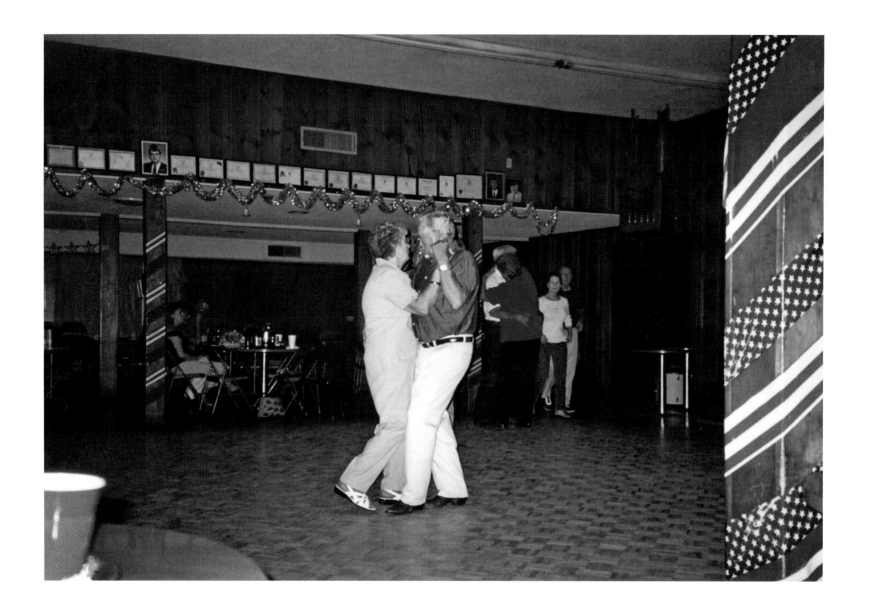

VFW Saturday night dance

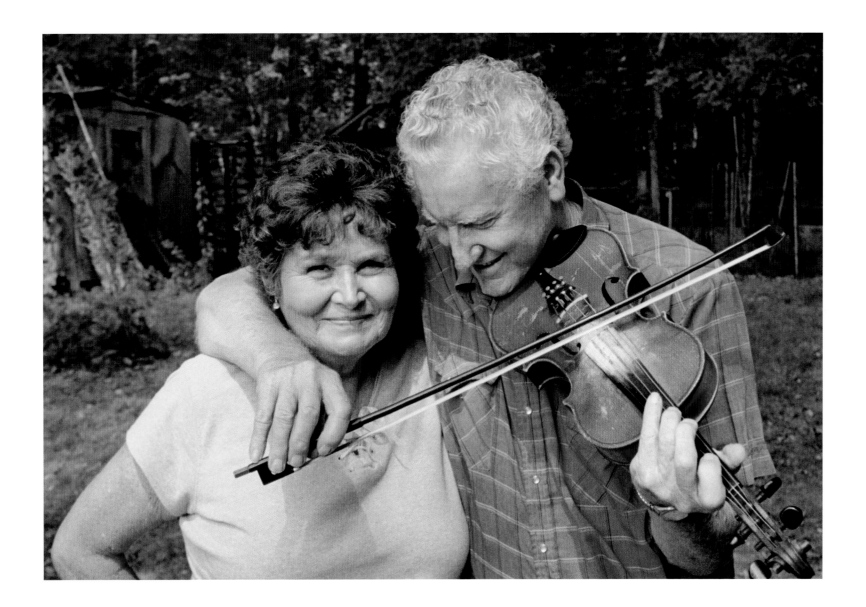

Curly Rainey plays for his wife

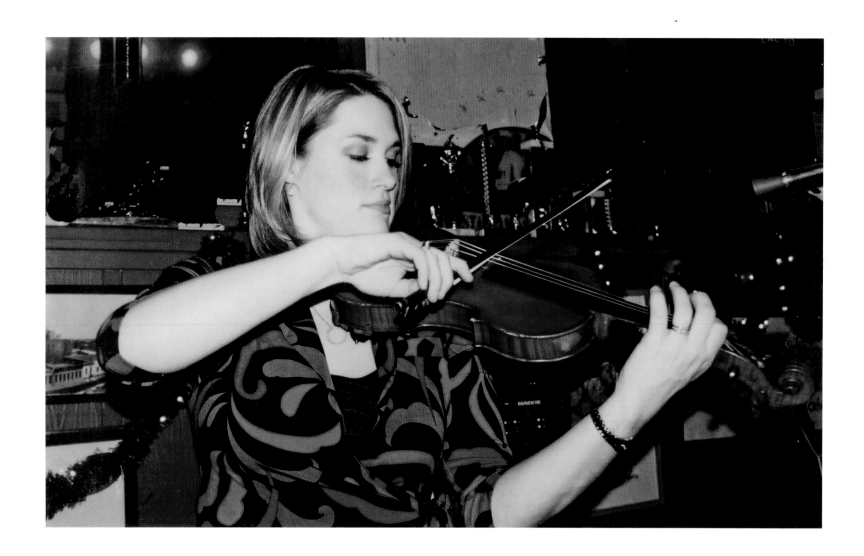

Bluegrass duo Temperance Babcock (left) and Bill Ellison,
host of NPR's *Grass Roots* (right), play at Hal & Mal's, Jackson

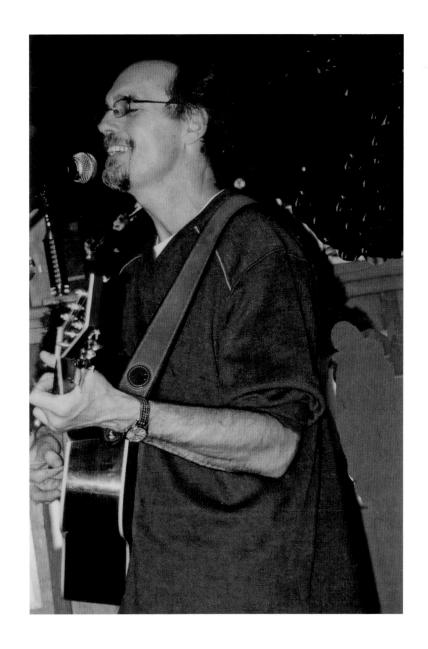

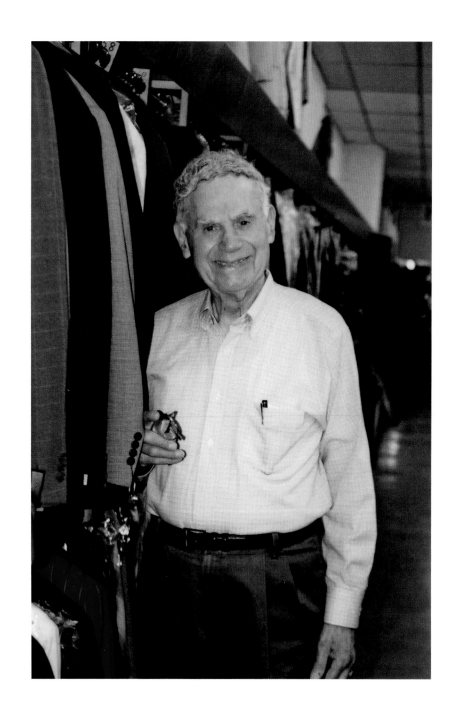

Mr. Buttross, of Buttross's Department Store, founded 1910, on the square at Canton

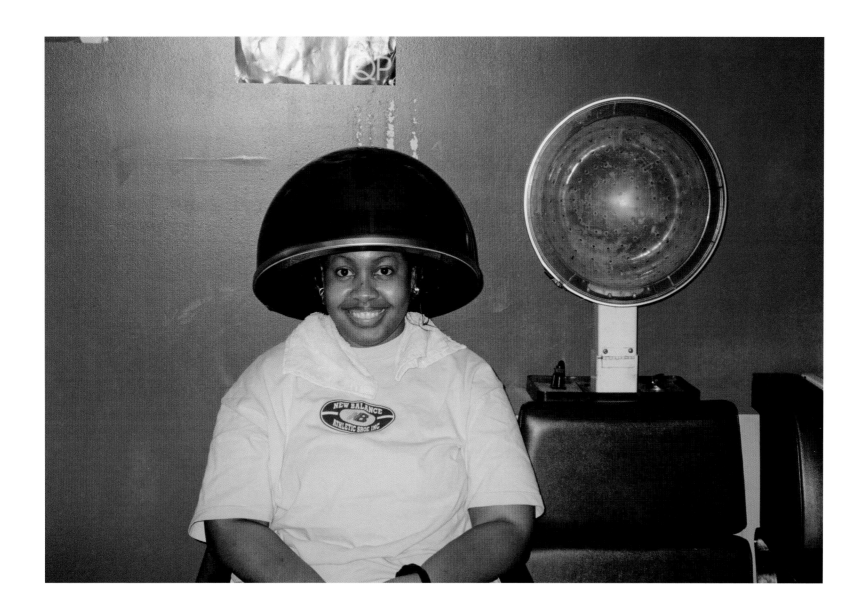

Woman at beauty shop, Como

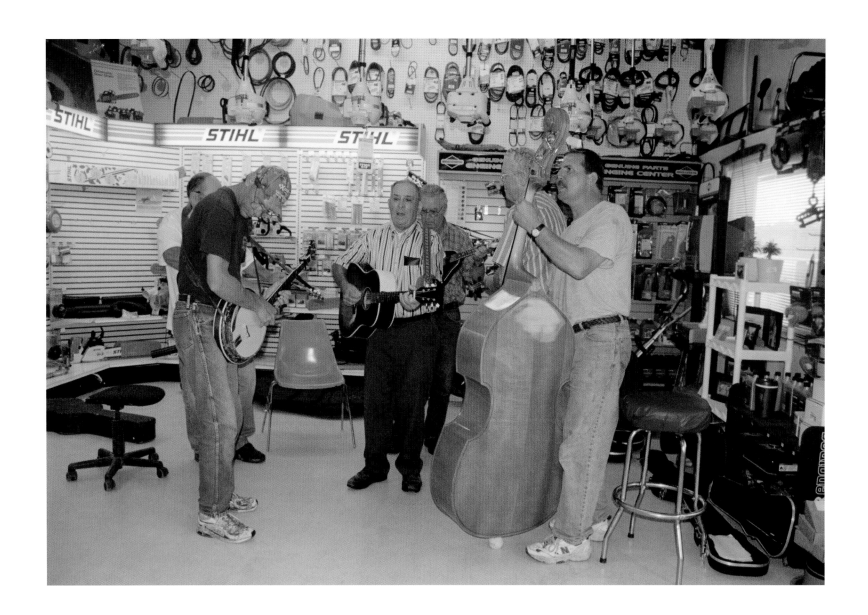

Duck Hillbillies practice on Monday nights in an auto store across from Heatcraft factory

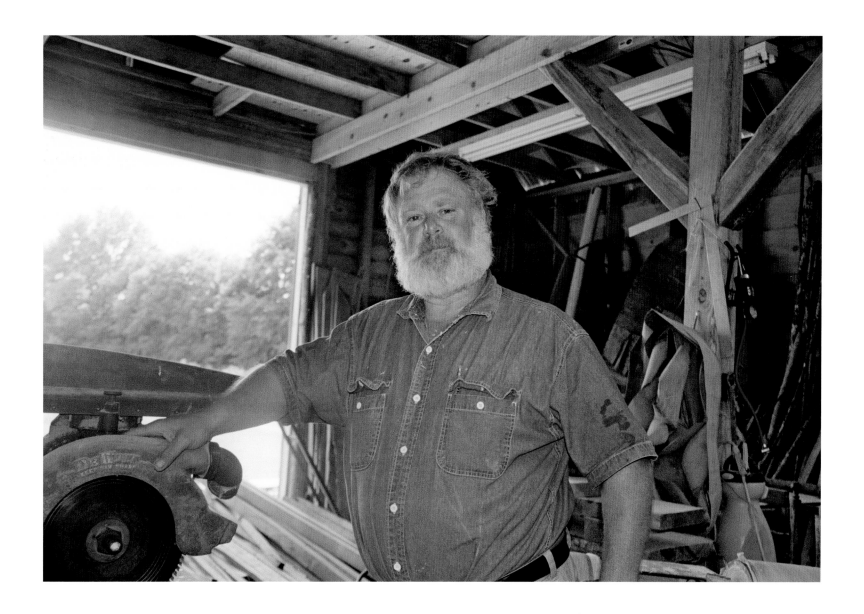

Greg Harkins, master craftsman of rocking chairs, Vaughn

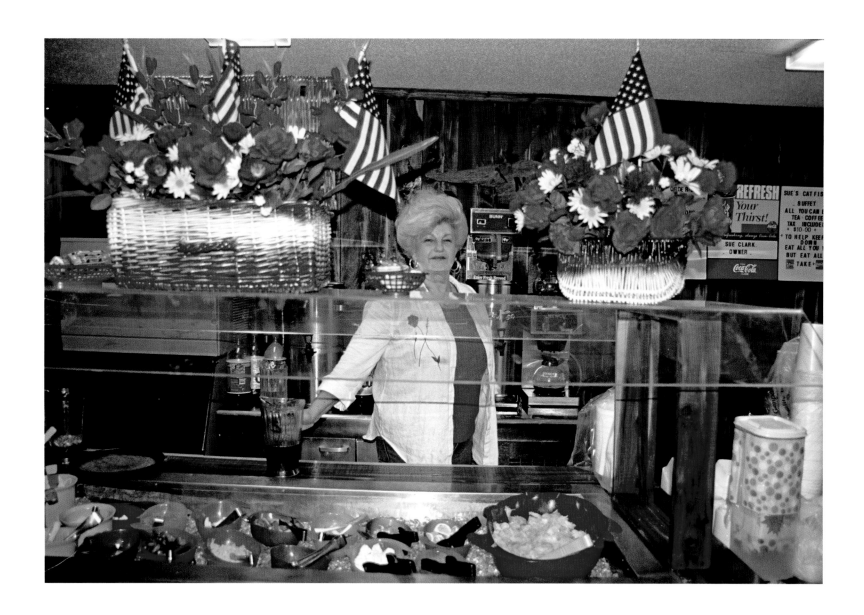

Sue, Sue's Catfish House, Fourth of July

Neighbors

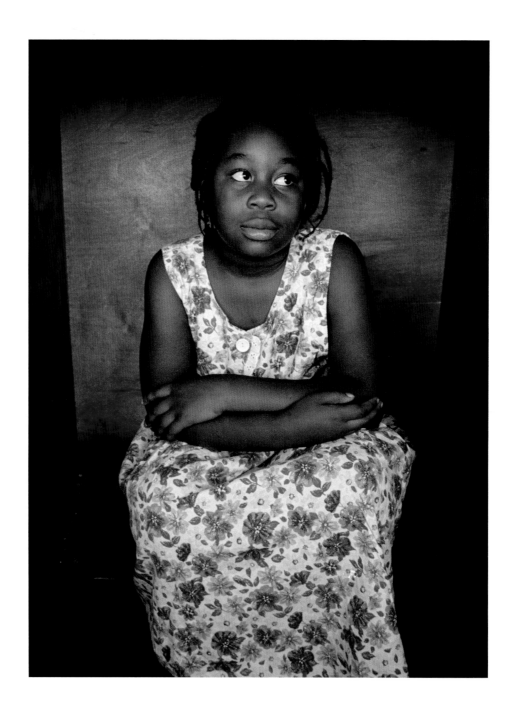

Young girl in blue sprigged dress

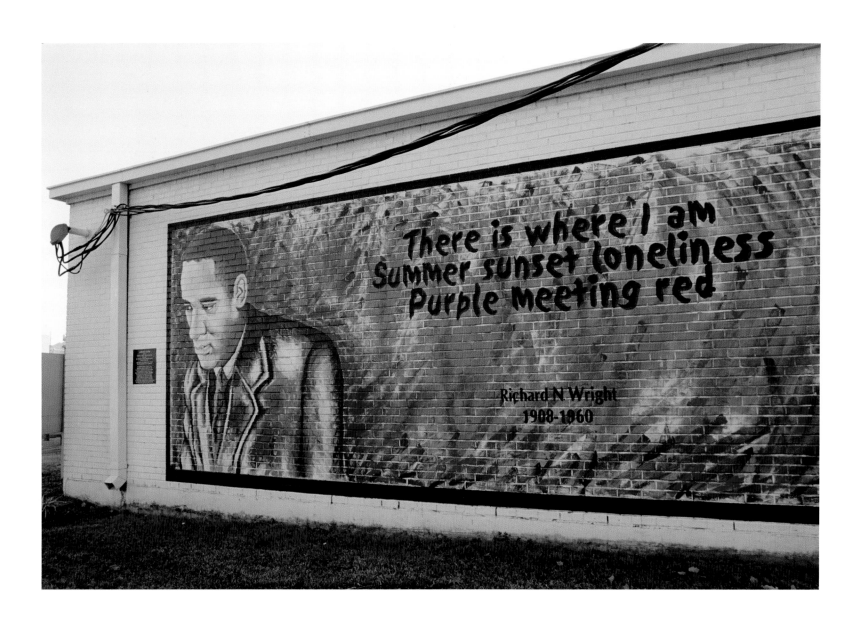

Mural of Richard Wright near the Jackson high school that he attended

Medgar Evers's driveway, Jackson

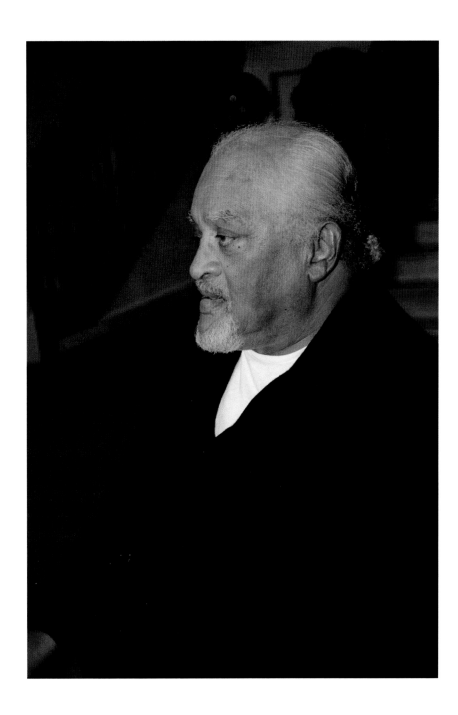

Civil rights activist

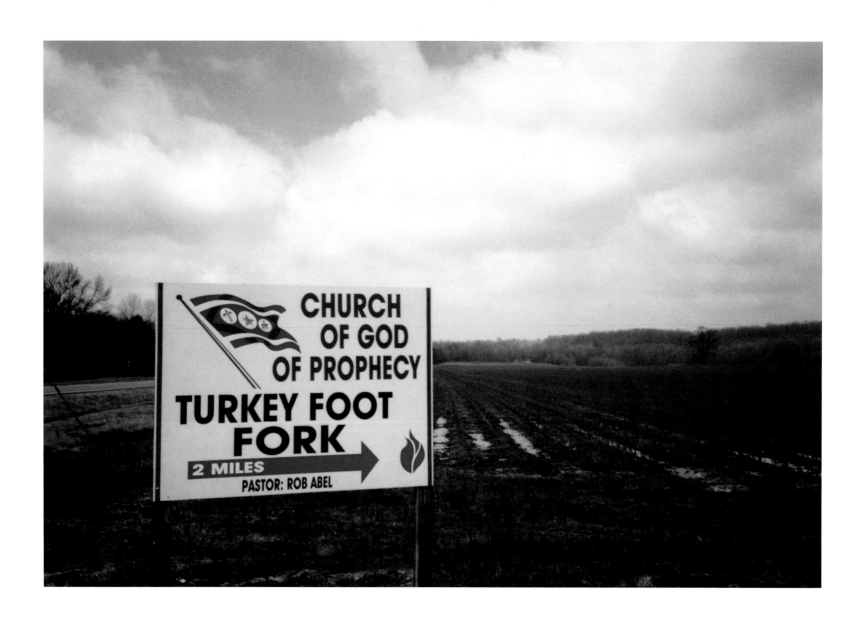

Church of God of Prophecy

Outdoor baptismal, Highway 51

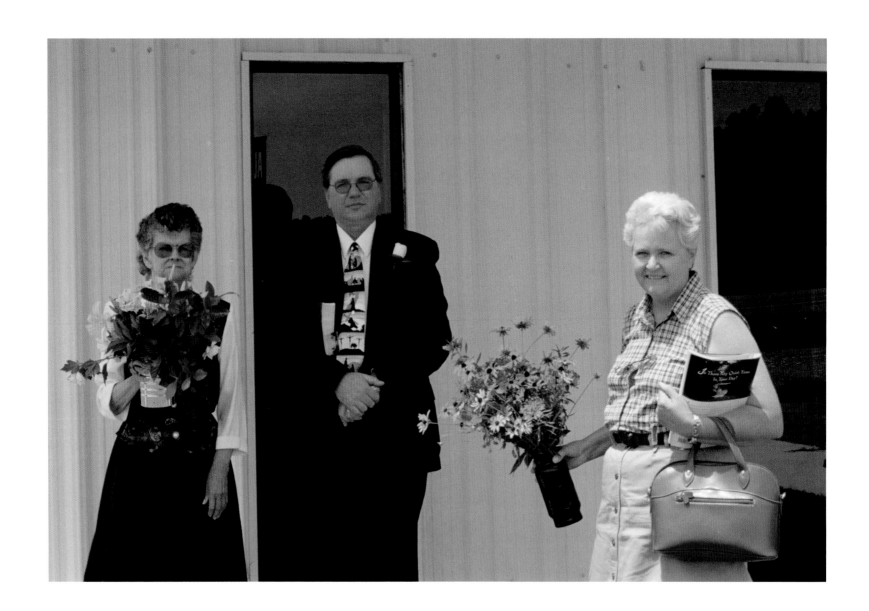

Pastor and deaconesses

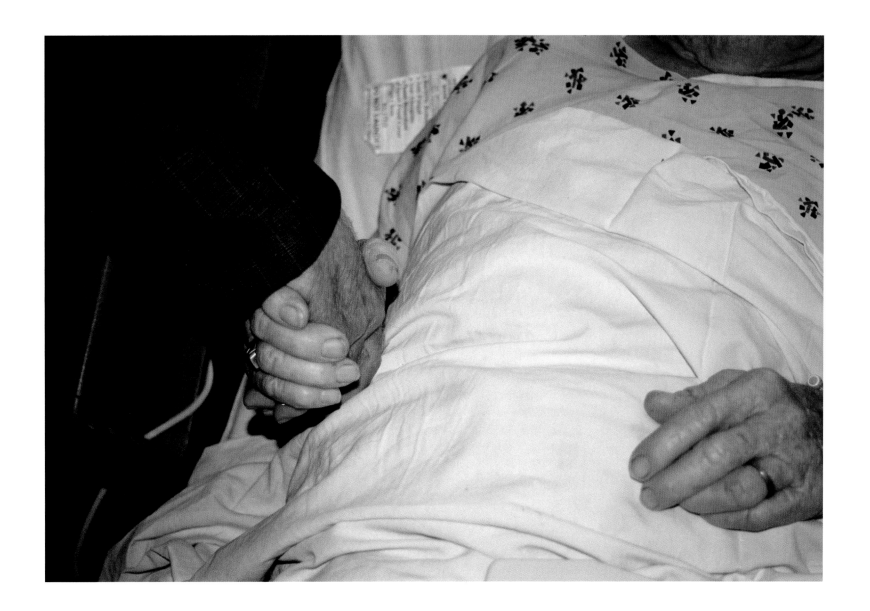

Minister comforting a hospital patient

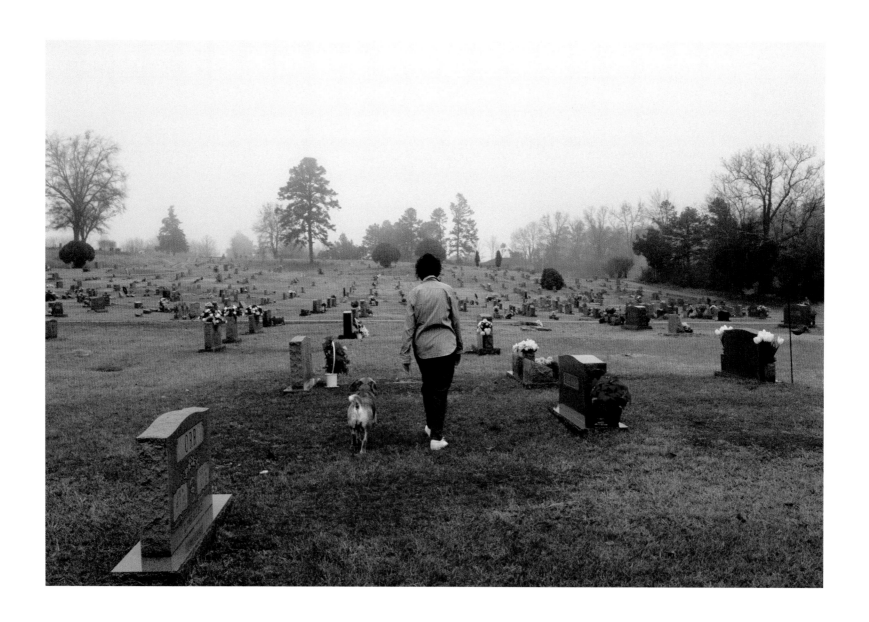

Woman on her daily visit to her husband's grave, Winona

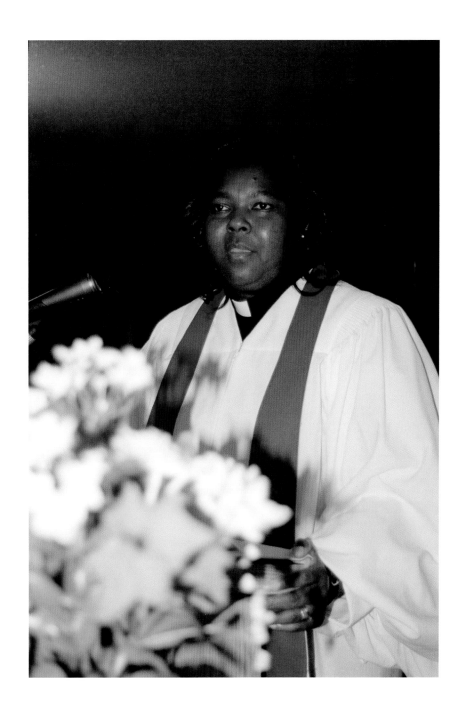

Minister, New Hope Methodist Episcopal Church, Holcomb

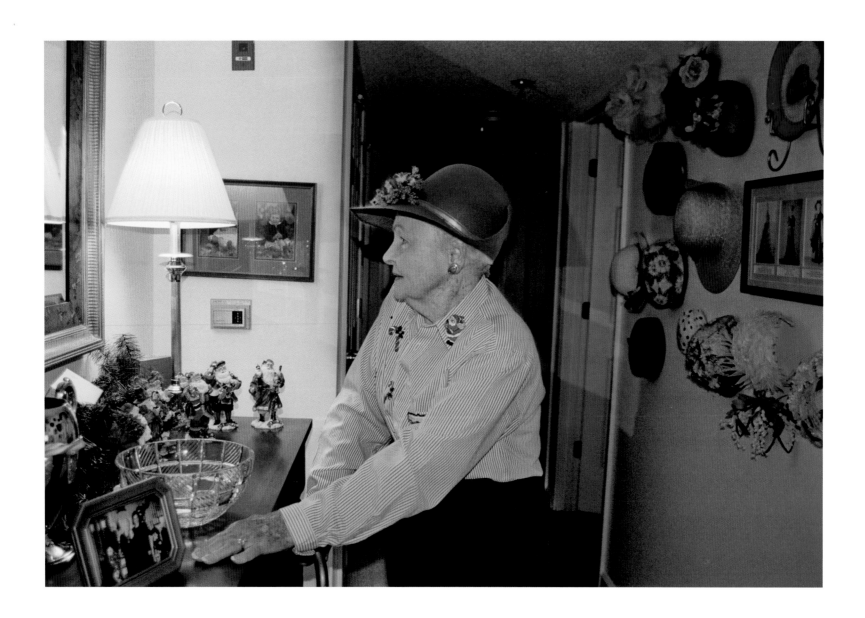

Lady with collection of her hats worn over the years, Hernando

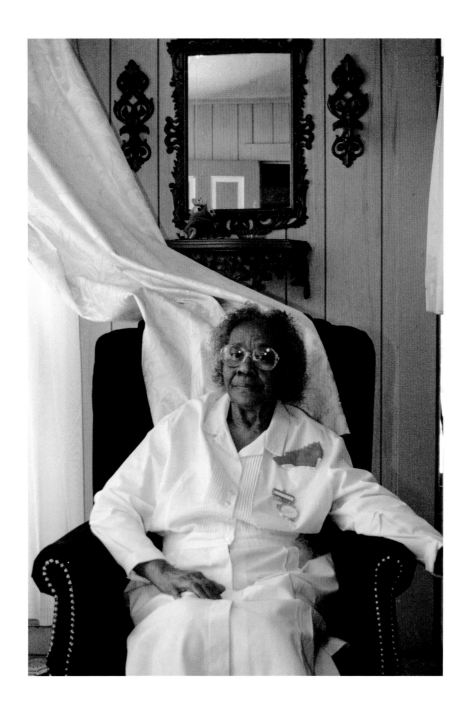

Jimmy Lee, in her church usher's dress

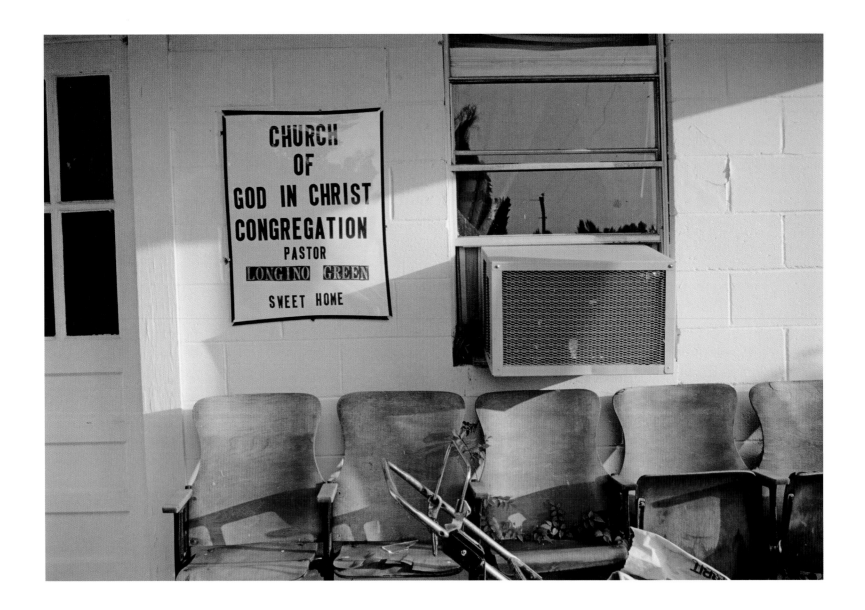

Church of God in Christ, Sweet Home

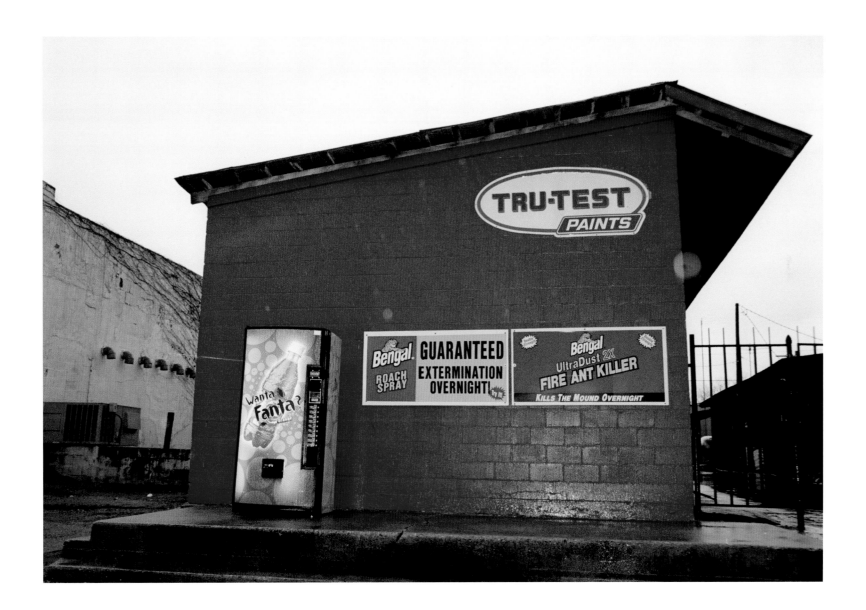

Tru-Test Paints, Sardis

71

Yellow hill pasture

Winter light

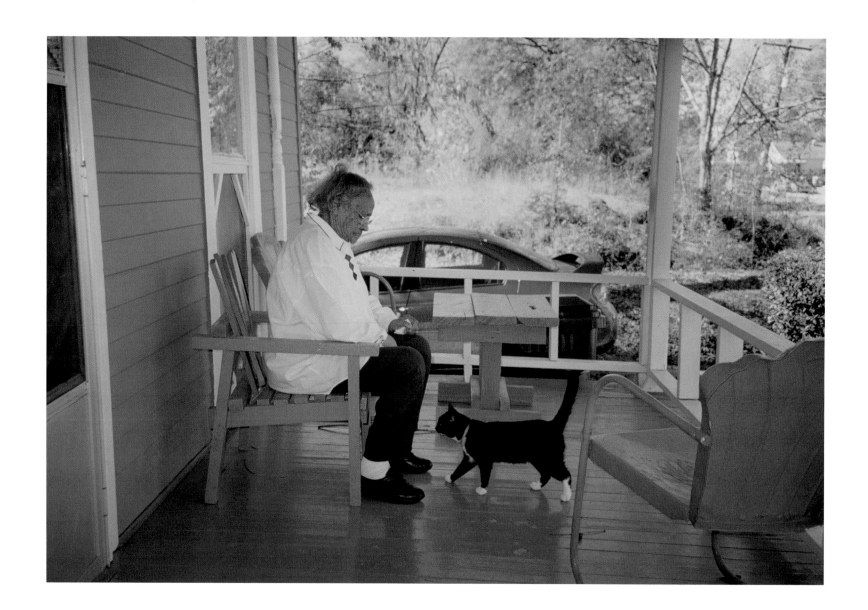

Home after the chemo

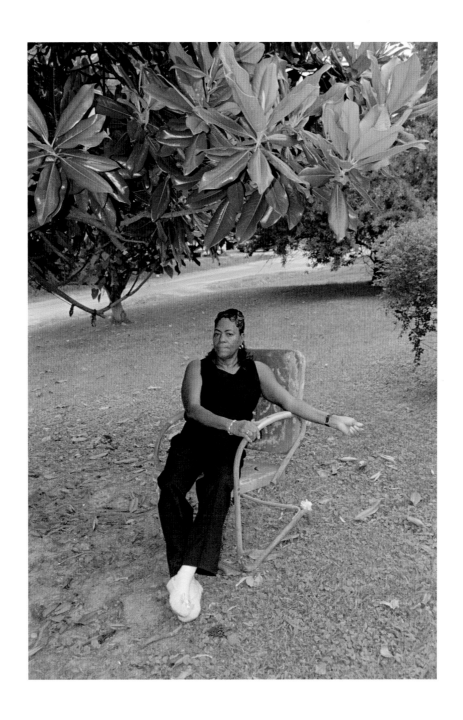

Irene Hurt Smith, oldest grandchild of Mississippi John Hurt, in her front yard

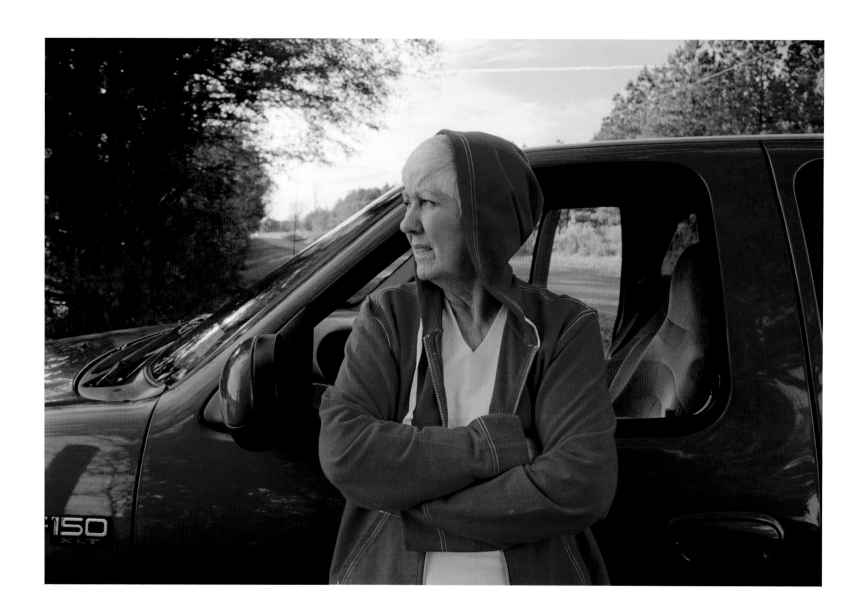

Lady in red

Hill town

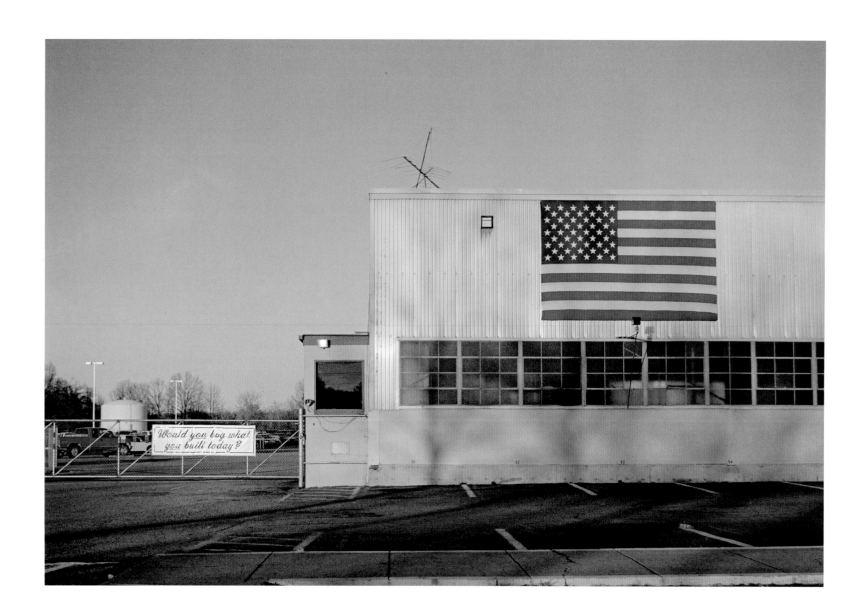

"Would *you* buy what *you* built today?"—Heatcraft Factory

Wonder Bread factory, Memphis

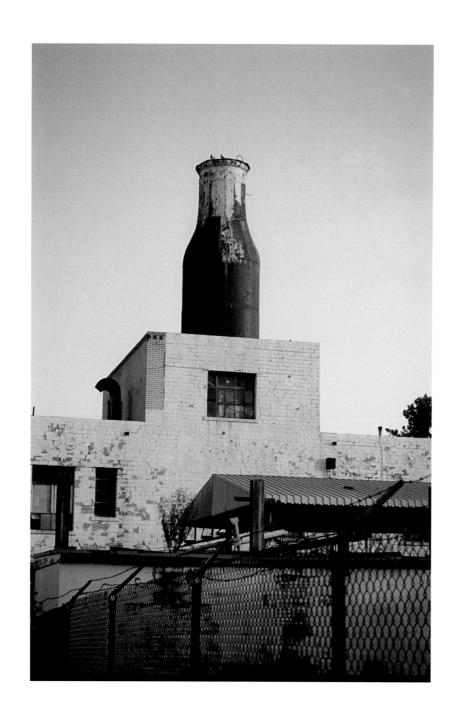

The "Milk Bottle" on Highway 51 leading into Memphis

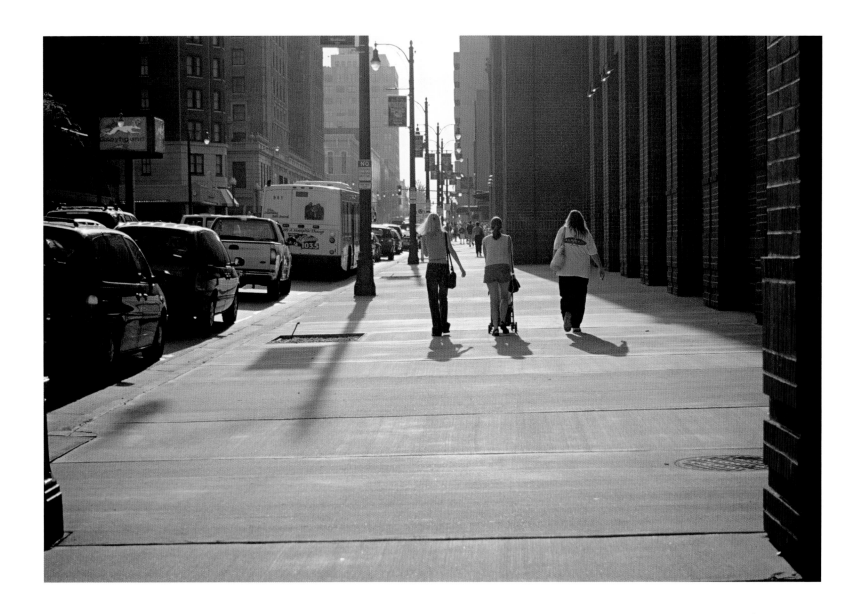

Highway 51 on Union Street, across from Greyhound bus terminal

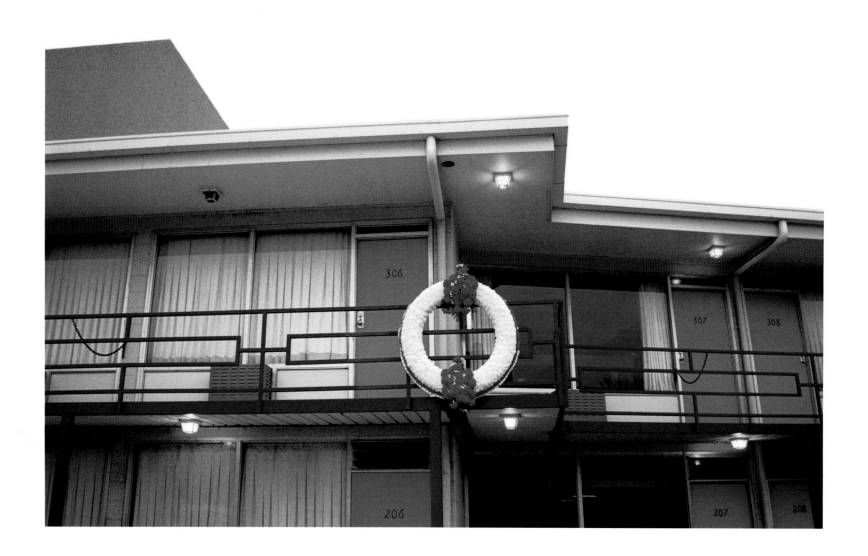

Lorraine Motel

Elvis's Caddy

Blue Jello at historic Piccadilly Cafeteria near Graceland

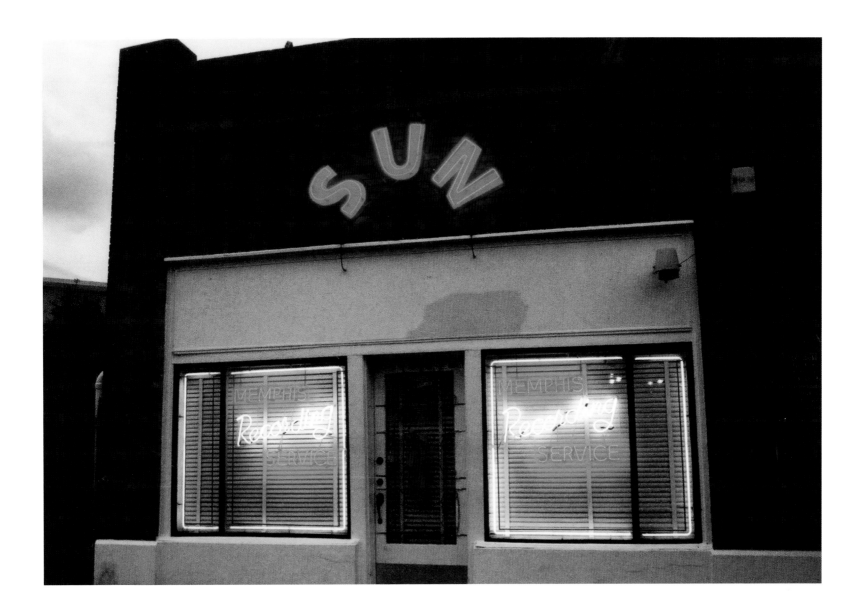

Sun Studio, Memphis, where Elvis, Carl Perkins, Jerry Lee Lewis, and many other stars got their start

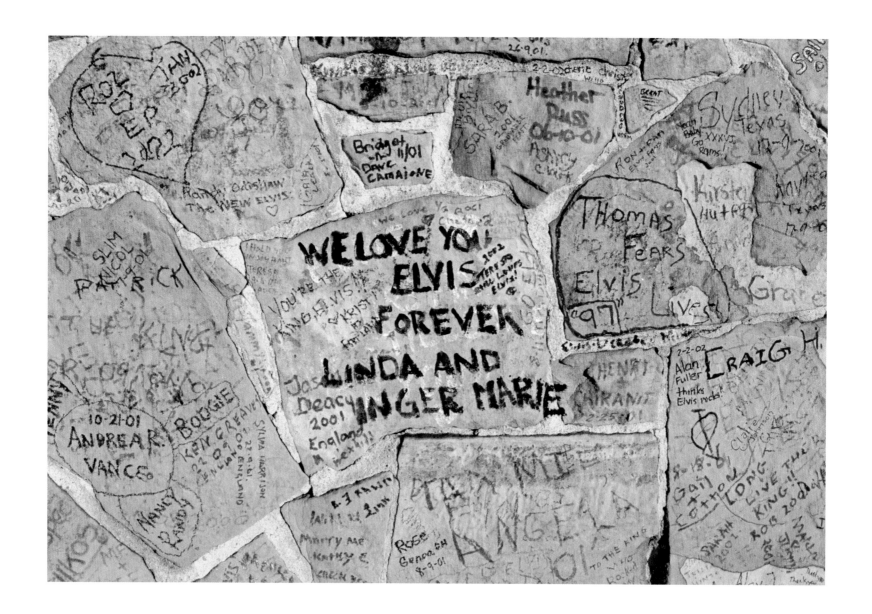

Tributes from fans on the stone walls surrounding Graceland

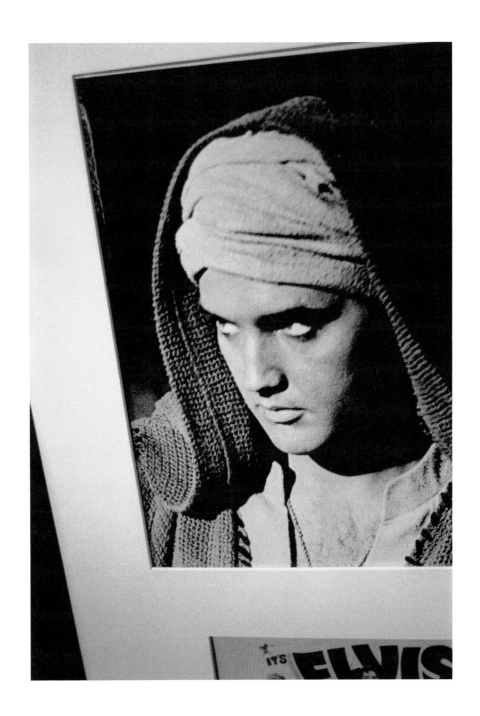

Photo of Elvis

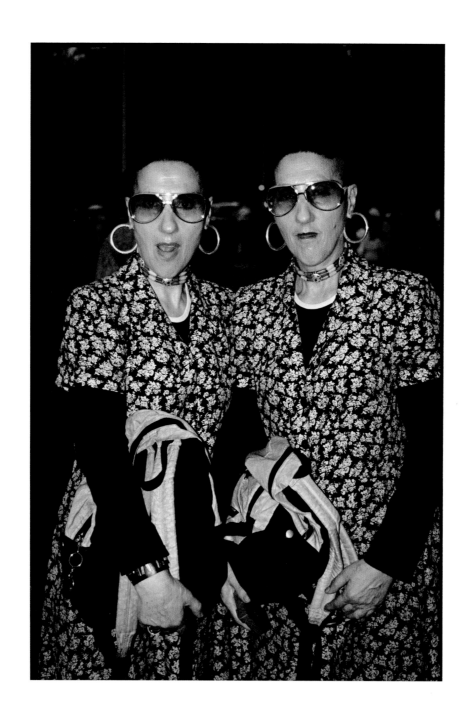

French sisters at Elvis's annual August birthday celebration

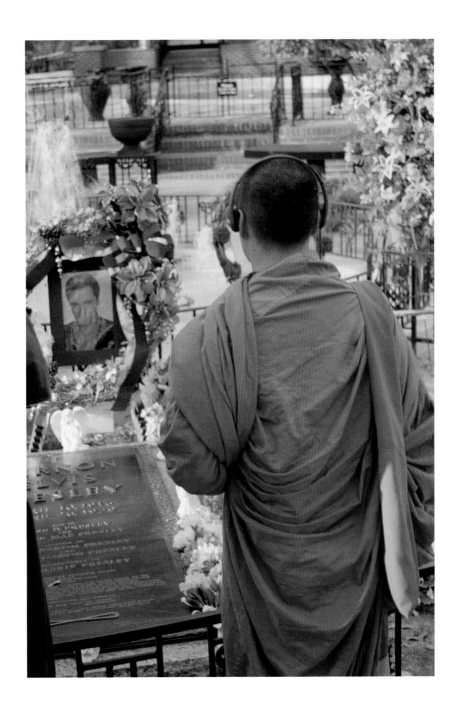

Buddhist monk at Elvis's grave

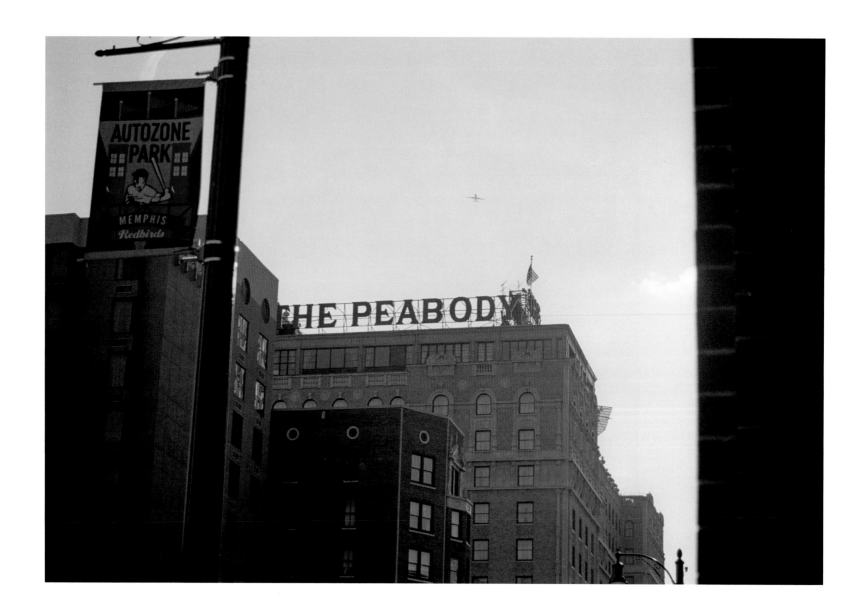

The Peabody

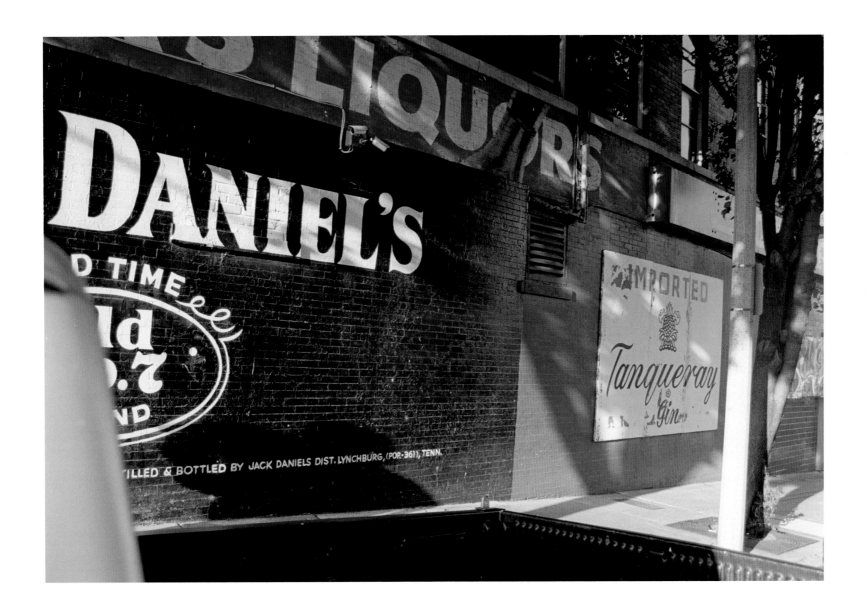

Memphis street in summer sun

First dark